ADVANCED

Calligraphy

TECHNIQUES
IDEAS IN ACTION
DIANA HOARE

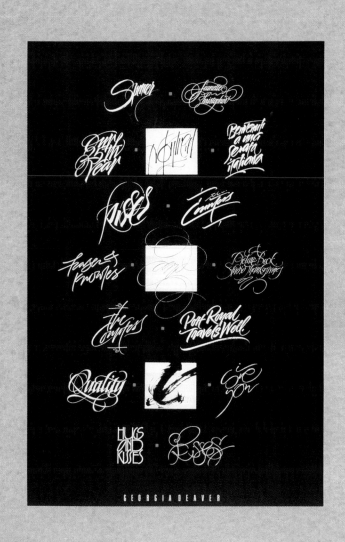

GEORGIA DEAVER

ADVANCED

Calligraphy

TECHNIQUES
IDEAS IN ACTION
DIANA HOARE

CHARTWELL
BOOKS, INC.

A QUARTO BOOK

Published by Chartwell Books
A Division of Book Sales, Inc.
110 Enterprise Avenue
Secaucus, New Jersey 07094

ISBN 1-55521-522

This book was designed and produced by
Quarto Publishing plc
The Old Brewery, 6 Blundell Street
London N7 9BH

Senior Editor: Sally MacEachern
Art Editor: Andy Turnbull

Editor: Leslie Levene
Illustrator: David Kemp

Photographers: Ian Howes and Paul Forrester

Art Director: Moira Clinch
Editorial Director: Jeremy Harwood

Manufactured in Hong Kong by Regent Publishing Services Ltd
Printed by Leefung-Asco Printers Ltd, Hong Kong

CONTENTS

*I*NTRODUCTION

Georgia Deaven

THE CRAFT OF CALLIGRAPHY - a Greek word meaning beautiful writing - has roots which stretch back into the mists of time. The techniques, tools, materials and some of the letter forms are much the same now as they were in the Middle Ages, and further back, but this does not mean that calligraphy has no part to play in the modern world.

The Chambers Twentieth Century Dictionary defines "technique" as a "method of performance". This book is concerned both with working methods for practicing calligraphers and with what they want their calligraphy to "perform" as a result of these "methods". In the West, we expect to see lettering running from left to right and from top to bottom in straight lines of varying lengths. However, the calligrapher has wonderful opportunities to break free from

the traditional mould and make letters perform visually as well as intellectually.

The modern student of calligraphy turns to historical models for an understanding of letter forms as they were used by earlier professionals. Before the invention of printing, calligraphy was vitally important as one of the few means of storing and transmitting the written word. For centuries scribes produced books by hand and we have much to learn from their methods of working and their lettering skills.

Print is primarily for reading, not for seeing. The vast amounts of written material to which we are exposed every day make us switch off our sensitivity to lettering. Newspapers filled with sensationalism, information on every packaged product, road signs, shop signs and street names all bombard us. The act of reading has become an everyday skill that most of us take for granted.

Calligraphy helps us to "see" what we are reading by making the words beautiful. Much of its impact relies upon producing a rhythmic texture in the writing. This beauty, however, is not necessarily peaceful. Tensions can also be used to disturb us. Seen in this light, calligraphy is a powerful tool for communicating the written word in the modern world.

DIANA HOARE

RHYTHMIC TEXTURE

WRITING of any sort, whatever the style, creates a texture on the page by the rhythmic linking together of repeated shapes and patterns, and this texture of the lettering is one of its most important qualities.

To draw a comparison, knitting is given texture by the constant repetition of stitches, and different areas of texture can be made to contrast with each other. But just as a dropped stitch can ruin the texture of knitting, so a misshapen or badly formed letter can ruin the texture of a piece of lettering. Whichever alphabet is used, the creation of texture through the constant repetition of shape, form and movement is the basis of the calligrapher's art.

Traditionally, each part of every letter of all alphabets is related to the shape of the letter "O" of that alphabet. In this way a series of related strokes can be built up to form the complete alphabet.

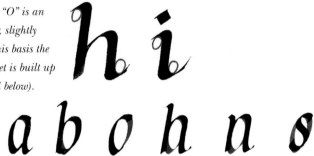

It was the cider country more especially which met the woodland district some way off. The air was blue as sapphire such a blue that outside the apple region is never seen. Under the blue the orchards were in a blaze of pink bloom, some of the richly flowering trees running almost to where they drove along. Hardy.

Formal Italic
The formal italic "O" is an oval-shaped letter, slightly slanting. From this basis the rest of the alphabet is built up (above, right and below).

mirum spargens sonum
the trumpet scattering a wondrous sound
per sepulcra regionum
through the graves of all lands
Coget omnes ante
will force all before the throne
thronum.

What a piece of work is man how noble in reason how infinite in faculty in form and moving how express and admirable in action how like a god the beauty of the world the paragon of animals & yet to me what is this quintessence of dust: man delights not me: Hamlet

Foundational or Roundhand
In the Foundational hand (above top), the shape of the letter "O" is round. It is possible to write any letter of the alphabet over the letter "O" (above). Even the serifs are rounded, and a tiny round "O" can fit into them (below).

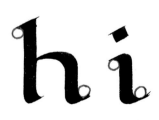

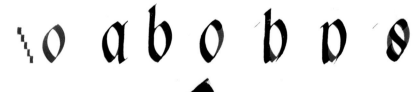

Gothic
The gothic adaptation of formal italic is based upon a sharply pointed, oval-shaped "O". The compressed nature of this hand makes a dark texture (above and right).

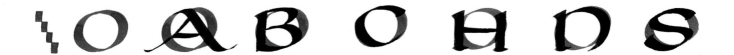

ON EITHER SIDE THE RIVER
LIE LONG FIELDS OF BARLEY
AND OF RYE THAT CLOTHE
THE WOLDE AND MEET THE
SKY AND THROUGH THE FIELD
THE ROAD RUNS BY TO MANY
TOWERED CAMELOT·AND UP
AND DOWN THE PEOPLE GO
GAZING WHERE THE LILIES
BLOW ROUND AN ISLAND THERE
BELOW THE ISLAND OFSHALOTT

Uncials
Uncials are wide letter forms based upon a round "O". The letters create an open texture, even though they are written with little space between the writing lines (above and left).

Versals
The same is true of drawn and painted capital letters. Each letter of this condensed versal alphabet bears some relation to the "O" shape in its proportions. By drawing the letter "O" you can establish the proportions of any other letter in the versal alphabet (left and below).

ALL THE
WORLDS
ASTAGE G
ALL THE

O A A O O D N D

REQVI
VE

By establishing a norm for the letters with a rhythmic texture the calligrapher can start to play with the size, position and color of letters to create different moods and visual effects *(right)*.

Here the spacing between the writing lines is varied. Also, spacing between the letters has been changed *(right)*.

all the worlds a stage
and all the men and
women merely player
they have their exits

all the worlds a stage
and all the men and
women merely player
they have their exits

DIES IRAE DIES ILLA DIES IRAE
SOLVET SAECLUM IN FAVILLA
TESTE DAVID CUM SYBILLA
QUANTUS TREMOR EST FUTURUS
QUANDO JUDEX EST VENTURUS
CUNCTA STRICTE DISCUSSURUS

The close texture in black and red creates an agitated mood (above).

H·O·S·A·N·N·A I·N
E·X·C·E·L·S·I·S

The open texture in black and red creates a joyful mood (above).

10

EM MASS
RDI

Moving the angle of the letters from the vertical and the lines from the horizontal to form a circle gives a sense of peace (right).

HMIN

OEIC.

uerscs iv, x &xi.

um porriget ei?

was written at Lindisfarne or Holy Island & is a very fine example of the Anglo-Irish half-uncial.

Sawras vel gehhidas ge 7 gesidd Alle donne vel foydon sum hauet

REX
TREMENDAE
MAJESTATIS

The color expresses a sense of majesty (above).

The regular ripples of the lines express the mood of the poetry (right).

Full Fathom Five
Thy Father Lies;

Of his bones are coral made,
Those are pearls that were his eyes
Nothing of him that doth fade
But doth suffer a sea change
Into something rich & strange
Sea nymphs hourly ring his knell
Ding Dong
Hark how I hear them
Ding Dong Bell.

Letter styles are interwoven to depict the subtle harmonization of different voices in choral music (below).

The height of the letters has been increased and decreased for emphasis, while a letter is made to symbolize the cross (right).

SANCTUS

SANCTUS

SANCTUS

REQUIEM REQUIEM REQUIEM

REQUIEM REQUIEM REQUIEM

KYRIE
ELEISON
CHRISTE
ELEISON
KYRIE ELEISON

ΕΙΘ᾽ ΩΦΕΛ᾽ ΑΡΓΟΥΣ ΜΗ ΔΙΑΠΤΑΣΘΑΙ
ΣΚΑΦΟΣ ΚΟΛΧΩΝ ΕΣ ΑΙΑΝ ΚΥΑΝΕΑΣ
ΣΥΜΠΛΗΓΑΔΑΣ ΜΗΔ᾽ΕΝ ΝΑΠΑΙΣΙ ΠΗΛ
ΙΟΝ ΠΕΣΕΙΝ ΠΟΤΕ ΤΜΗΘΕΙΣΑ ΠΕΥΚΗ
ΜΗΔ᾽ΕΡΕΤΜΩΣΑΙ ΧΕΡΑΣ ΑΝΔΡΩΝ
ΑΡΙΣΤΩΝ ΟΙ ΤΟ ΠΑΝΧΡΥΣΟΝ ΔΕΡΑΣ ΠΕ
ΛΙΑ ΜΕΤΗΛΘΟΝ. ΕΥΡΙΠΙΔΟΥ ΜΗΔΕΙΑ.

If only they had never gone. If the Argos hull had never winged out through the blue grey jaws of rock And on towards Colchis. If that pine on Pelions slopes Had never felt the axe, and fallen to put oars Into those heroes hands who went at Pelias bidding, To fetch the golden fleece. An Extract from Euripides Medea, which dates from 431 B.C. D.C. Hoare scripsit 10 January 1980.

These letters are similar to historic examples, but they have been adapted by changing the pen angle from parallel to the writing line to an angle of 30° (left).

THE POPLAR FIELD

THE POPLARS ARE FELLD FAREWELL TO THE SHADE AND THE WHISPERING SOUND OF THE COOL COLONNADE
THE WIND PLAY NO LONGER NOR SING IN THE LEAVES NOR OUSE ON ITS BOSOM THEIR IMAGE RECEIVES
TWELVE YEARS HAVE ELAPSED SINCE I FIRST TOOK A VIEW OF MY FAVOURITE FIELD AND THE BANK WHERE THEY GREW
AND NOW IN THE GRASS BEHOLD THEY ARE LAID THE TREE IS MY SEAT THAT ONCE LENT ME A SHADE
THE BLACKBIRD HAS FLED TO ANOTHER RETREAT WHERE THE HAZELS AFFORD HIM A SCREEN FROM THE HEAT
AND THE SCENE WHERE HIS MELODYE CHARMED ME BEFORE RESOUNDS TO HIS SWEET FLOWING DITTY NO MORE
MY FUGITIVE YEARS ARE ALL HASTING AWAY AND I MUST ERE LONG LIE AS LOWLY AS THEY
WITH A TURF ON MY BREAST AND A STONE AT MY HEAD ERE ANOTHER SUCH GROVE SHALL RISE IN ITS STEAD
TIS A SIGHT TO ENGAGE ME IF ANYTHING CAN TO MUSE ON THE PERISHING PLEASURES OF MAN
THOUGH HIS LIFE BE A DREAM HIS ENJOYMENTS I SEE HAVE A BEING LESS DURABLE EVEN THAN HE.

WILLIAM COWPER

Large and small letters of the same sans-serif style are juxtaposed (left).

These letters are more like the Greek unicals (above left), in the angle of the pen and in the forms of "H" and "N". (below) A basic understanding of letter forms also enables the calligrapher to design new letters and to combine lettering with illustration. To work well, something of the texture in the lettering should be conveyed by the style of illustration.

A FORSAKEN GARDEN
IN A COIGN OF THE CLIFF BETWEEN LOWLAND AND HIGHLAND
AT THE SEA DOWNS EDGE BETWEEN WINDWARD AND LEE
WALLED ROUND WITH ROCKS AS AN INLAND ISLAND
THE GHOST OF A GARDEN FRONTS THE SEA·
A GIRDLE OF BRUSHWOOD & THORN ENCLOSES
THE STEEP SQUARE SLOPE OF THE BLOSSOMLESS BED·
- WHERE THE WEEDS THAT GREW FROM
THE GRAVES OF ITS ROSES
NOW LIE DEAD·

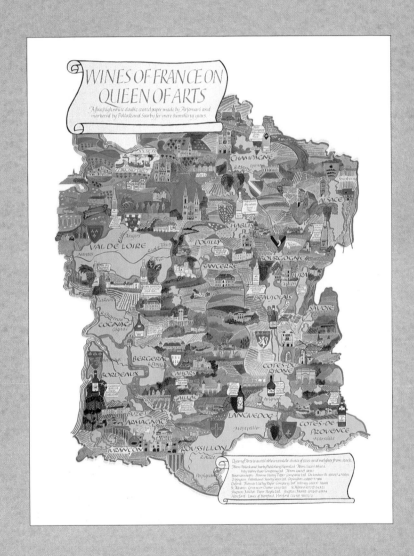

DECORATIVE POSTER

THE poster was to have two roles: it was to act both as a plan that would be useful for visitors to Michelham Priory Sussex, England and as an attractive souvenir. It therefore had to marry contrasting elements of formality and informality.

Formal and informal

The heraldry was executed in a modern style. This was colorful and formal at the same time. Heraldry contains both symmetrical and asymmetrical elements, and these played an important part in the design of the poster.

Italic was chosen for the text because it combines a degree of stylistic freedom with relative formality. The nib size was governed by the amount of information required. By using a small nib, compressing the writing and making the writing lines fairly close together, a dense black texture was obtained. This was lightened and given sparkle by the larger red titles, which relieved the heavy texture of the lettering, catching the eye and leading it on from paragraph to paragraph.

Drawing for the plan

Wherever possible decorative features of the map were used to provide opportunities for making pen-pattern textures. These helped to strengthen the relationship between the map and the text. The angle at which the pen was held was maintained so that the thick and thin qualities of the strokes would be constant and relate directly to the strokes of the lettering.

The tree symbol was made with a pen and then filled in. A strong pen characteristic was maintained throughout, and despite the "infilling", it was not a painted or drawn form but a pen-made shape. The process was reminiscent of the making of a versal letter. The outer shape was drawn with the pen at a 30º angle and the inner shape was then flooded

BRIEF:

To design a poster combining heraldry, text, map, illustrations and title.

TIME LIMIT: Two months.

SOURCES: Postcards, photographs, plans, guidebooks and transparencies.

DIMENSIONS: 60 x 46cm (24 x 181/2 in). The size had to suit the printer's laser-scanning equipment, since the map was to be used twice, once framed and hung in the entrance of the Priory, a second time as artwork for printing posters.

Formal symbols for the map: (right) ripples in the moat, (far right) freely flowing water; trees - first draw the outline, then flood in with a brush (bottom).

Experiments with free and formal italic meant that this free style version was discarded in favor of a formal version.

Plan of Michelham Priory

The intricate detail of Persian miniatures provided the inspiration for the style of illustration chosen.

with paint from a brush up to the pen outline. The arrangement of the tree symbols allowed for more decoration. Rather than being scattered at random over the area, they were arranged in a diaper pattern. This formal and stylized use of the pattern element tied in well with the stylized formality of the lettering.

Two different water symbols were used. They relied on the thick and thin qualities of the pen stroke, one suggesting the ripples in the water of the moat, the other indicating the freely flowing river water.

Illustration

The illustrations themselves were taken from the source material provided - postcards, guidebooks and photographs. I have evolved a style of illustration from studying Persian manuscripts, where there is a strong sense of pattern and decoration in the images.

Line drawings were made from the source photographs. The areas of different colors needed for different parts of the buildings were shown in this study but not fully completed. To make them more two-dimensional, they were presented head-on even if the original source showed the building at an angle. The outline of the buildings made an irregular shape on the page. The flat, two-dimensional qualities of these images complemented the two-dimensional qualities of the lettering, and the texture of the lettering was carried over into the texture of the pattern in the illustrations, in the detail of stone, brick and tile and of leaves, plants and flowers.

Title

The title was the linch-pin of the design as a whole. Various lettering styles were compared to see the effect of a contrast with the italic of the text, but the flamboyant color and distinctive pattern of the heraldry placed at the top was providing sufficient contrast already. As a result, the italic style, with a large nib size, was finally chosen to unite all the lettering. The blue color of the title made a link with both the heraldry and the map while providing a contrast with the black ink of the main text.

Design

Edward Johnston suggests that the ideal proportions for the margins of a broadsheet should be: 1:1.5: 2, and traditional, tried and tested solutions tend to work well. This format is based on the theory that the optical center of an object is higher than the actual

A PLAN OF MICHELHAM
A PLAN OF MICHELHAM

A PLAN OF MICHELHAM

Further experiments with lettering (top) Sans seriph (bottom) uncial confirmed the choice of italic for the title - this would unite all the lettering.

center - a rule that is important in the design itself. Thumbnail sketches help you to visualize just how the various elements will work together.

Since the information was fairly compressed, the text was broken up by illustrations and was written in narrow columns to make it more interesting and easier to read. The juxtaposition of text blocks and illustrations allowed for variety and movement within the formal composition. The weight of the pictures supported the weight of the text. The play of text against illustration created an asymmetrical balance. By contrast, the two balancing columns of text made an overall symmetrical design, with the plan forming the centerpiece. The two pictures of the Gateway Tower are echoed by the two columns, which themselves look like towers.

The 13 different heraldic shields which had to be incorporated into the poster were placed above the text with the title. This was to give the top of the page weight with which to balance the weight of the writing beneath.

Mechanical rough

Having decided upon the basic layout of the piece in a small pencil sketch, the next stage was to transfer this up to the size of the finished artwork. Working on a piece of layout paper of the correct dimensions, which in this case were 60 x 46 cm (24 x 181/2in), the size of the margins must be determined and ruled in pencil. You can then work on fitting the text and illustrations into the available space.

Lettering trials

Carry out lettering trials for the title and the text on separate pieces of layout paper with various nib sizes and spaces between the lines. To establish if the text will fit into a given

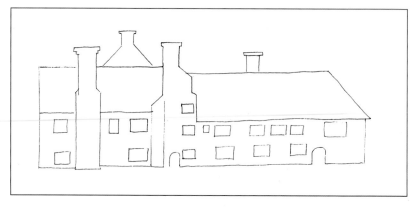

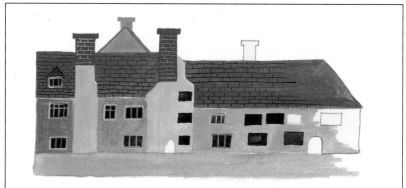

Using a photograph of the Priory as reference, a pencil drawing was made. The next step was a partial color study exploring the textures of brick, tiles and windows (above).

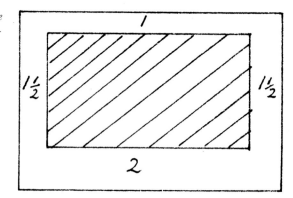

Traditional margin proportions for a broadsheet (above).

The formal italic style chosen for the title (below).

A Plan of Michelham Priory

Thumbnail sketches of the layout. The first (far left top) is top-heavy and does not accommodate all the information; the second (left) includes all the information, but the narrow text columns give it a fragmented appearance; the third (far left below) is bottom-heavy.

Thumbnail sketch of the chosen design.

Find a sample of lettering in the required nib size. Place a clean sheet of layout paper over this. Write the text out in pencil. This is a time-saving way of making sure the text fits at that size.

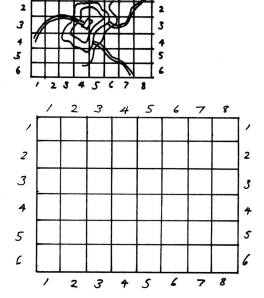

Grid up the source map so that it can be redrawn at the desired size.

The enlarged grid ready for redrawing.

space in a certain nib size, write it out roughly in pencil instead of ruling-up, to save time. Working on a light table, place a piece of clean layout paper over a sample of lettering of the required nib size to act as a guide. If the text is too long, a smaller nib size or different spacing may be necessary.

A pen-written rough is the only way to establish with complete accuracy the line length and overall text block. This can then be cut up and pasted on to the rough.

Gridding up the map

The plan was adapted from a guidebook and redrawn to the appropriate scale by gridding up the source map and drawing another grid to the same proportions for the finished artwork. Having established the size and details of the plan in pencil, the decorative pen features were carried out in study form. This study was to establish exact colors and sizes of symbols, and was still an unfinished rough.

Once the study of the plan, the illustrations, heading, heraldry and text roughs had been completed on individual pieces of paper, they could then be assembled together on to a full-size rough. The final layout was considered and a pasteup rough was made.

All the loose pieces were put on to a sheet of layout paper over which a piece of glass was placed. This was done to prevent any distraction from the curled edges of the separate pieces of paper. Once the layout and positioning of the individual elements are satisfactory, they can be pasted up carefully so that all the edges are stuck down.

Artwork

The finished artwork must be very accurately ruled up and the illustrations and plan traced on before any work with ink or paint is begun. One way to achieve this is to rule the work up with a T-square on a drawing board with a ruler.

The tracing of the illustrations, heraldry and plan can be made from the finished rough by using a light table. Place the finished rough mechanical on the writing surface of the light table and lay the paper for the fin-

ished rough, or even the final artwork, face up on top of the rough. The paper has already been ruled up at this stage, so you know exactly where the tracings are to fit. With the light table on, the images of the finished rough will be visible, even through heavy watercolor paper. In this way you can effectively redraw the image from the rough to the finished piece, without leaving any unsightly indentations from pressing too hard through tracing paper. Such marks are hard to conceal, even under paint.

Once the artwork is fully represented in pencil outline and the text ruled up, then work on the finished artwork can begin. Chinese stick ink, rubbed down with distilled water, and vermilion watercolor were used for the lettering of the text and the red titles. The illustrations and other colored lettering were executed with artist-quality watercolor.

Beginning with the main title - possibly the most daunting part - the red titles were put in, and then the black writing, the painting of the heraldry and finally the illustrations.

The buildings were painted in flat blocks of color and the details of brick, tile and stone were added when the flat color was completely dry.

Text and calligraphy by Diana Hoare

The finished artwork ready for printing - 60 x 47.5cm (24 x 181/2in).

Plan of

Michelham Priory:
The Priory was founded in 1229 by the Norman Lord of Pevensey, Gilbert de l'Aigle & was first colonised by canons from Hastings Priory. The founder endowed it with much land & the buildings were gradually erected during the following hundred years. A little before 1400 the great moat was dug & the gatehouse was built. The Priory was dissolved in 1536 by Henry VIII and two thirds of the buildings were destroyed. Later in the 16th century the remaining monastic buildings were repaired & incorporated into two Tudor houses & the 1000 acre estate became a working farm. The Sussex Archæological Society was presented Michelham in 1960.

Grounds & Gardens:
Leaving the Priory by the South door, from the South lawn you have a fine view of the buildings. The refectory to the right was built of Sussex sandstone containing iron ore. On your left are the two Tudor buildings, built of Pevensey greensand. The roof of the early house can be seen beyond it; high up, the chimney stack & gable of the Prior's guest room showing the height of the medieval structure. On the south lawn by the house is a monastic style Physic garden established in 1981 containing 100 plants which were used in the middle ages for culinary and medicinal purposes. From the south lawn the arches of the original windows of the refectory can still be seen & the extent to which the roof was lowered.

Great Barn:
this is Tudor made of oak & elm and was reroofed with Sussex tiles, although originally thatched.

Car Park / Watermill / Sluice / Picnic Area / Sluice / Rope, Wheelwright Forge Museums

Michelham Priory

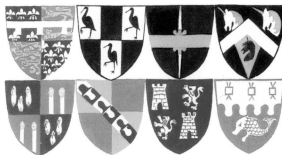

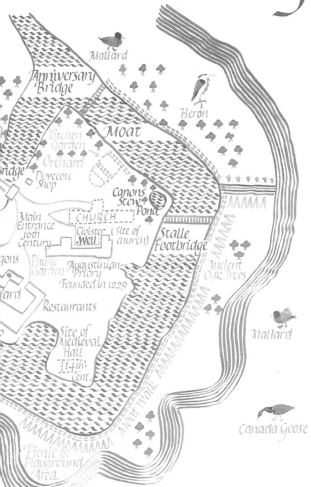

The Monastic Layout:
The centre around which the buildings were grouped was the cloister, an expanse of turf some 70 feet square surrounded by a covered, paved walk. On the north side of the square stood the church running east west. The north walk is sheltered from the wind & sun although open & was used by the canons for teaching. On the east side stood the chapter house with dormitory above.

Existing Monastic Buildings:
Of all the buildings so far described nothing remains above ground at Michelham; but the outlines of the church & western range have been revealed by excavation & marked on the ground. On the south side of the cloister stands the shell of the Refectory or Dining Hall although much altered since Tudor times.

The Watermill:
was probably established in the 13th Century but the first recorded mention is dated 1434. It stands on a medieval site & has been rebuilt several times. The present oak framing dates from the 15th and 16th centuries with

18th century brickwork and nineteenth century weatherboarding. An iron waterwheel was installed in 1896 & was removed with other grinding equipment in 1925, when it ceased functioning as a working mill. The mill was restored to working condition in 1970 & now grinds local wheat into bread flour. The mill is powered by fall of water from the moat to the level of the river below. Diana C. Hoare scripsit April 1986. 27, Longburton, Sherborne, Dorset, DT9 5PG. Tel. Holnest 624.

...y Tower:
was ...ior Leem about 1395 ...riginal condition. ...vith Eastbourne green ...ing chalk & flint, ...et thick. The tower ...gh to the parapet & ...ide leaded walk ar- ...p giving extensive ...ither side of the ent-

rance there were originally porters rooms. Two upper rooms have original floor timbers, interesting window sills & two, two-light windows. The present approach bridge is older than the tower and replaces an earlier drawbridge.

Map labels: Mallard, Anniversary Bridge, Heron, Moat, Kitchen Garden, Orchard, Dovecote Shop, Canons Stew Pond, Main Entrance 16th Century, CHURCH, Cloister (Site of church), Well, Stalle Footbridge, Physic Garden, Augustinian Priory Founded in 1229, Restaurants, Site of Medieval Hall 114th Cent., Ancient Oak Trees, Mallard, Canada Goose, Moat Walk, Picnic & Playground Area

ILLUSTRATION

Cindy Wonnacott
SEAFARERS
SUPERSTITIONS

92 x 56cm (36 x 22in)
Italic and free capitals on
Fabriano 5 paper, using a
metal nib. Watercolor with
pencil illustration.

THERE IS BUT A PLANK BETWEEN A SAILOR AND ETERNITY
AND PERHAPS THE OCCASIONAL REALISATION OF THE FACT
MAY HAVE HAD SOMETHING TO DO WITH THE BROAD GRAIN OF
SUPERSTITION AT ONE TIME UNDOUBTEDLY LURKING IN HIS NATURE

Fear of the unknown is the core of superstition

The dangers of the sea are changeless and so many
of the powerful superstitions of the past still survive.
These superstitions take three main forms, firstly, certain actions result
in bad luck, desirable results can be brought about by performing specified
rituals and thirdly there are omens and portents
which if correctly divined can interpret events for good or evil.

THE WORD DROWNING IS NEVER SPOKEN AT SEA BY SEAFARERS
IN OLDER GENERATIONS SAILORS NEVER LEARNED TO SWIM
THOUGHT IT BEST NOT TO PROLONG PAINS OF DEATH
THERE WAS A DREAD OF BRINGING BACK ANY CORPSE
FOUND FLOATING IN THE SEA

'I saw the moon late yestreen
Wi the auld moon in her arm
And if we gang to sea master
I fear we'll come to harm.'

Seagulls were thought to be the souls of drowned fishermen and three in flight together were
a dreaded death omen. The sighting of a petrel was a storm warning and the albatross
was thought to embody the restless
soul of some dreaded mariner.
An albatross flying around the ship
in mid ocean was an omen of bad weather
to come and to kill one fatal

'And I had done a hellish thing,
And it would work 'em woe
For all averred
I had killed the bird
That made the wind to blow
Ah wretch! said they the bird to slay
That made the wind to blow'

IN 1958 THE CARGO LINER 'CALPEAN STAR' DOCKED
AT LIVERPOOL AFTER MANY MISFORTUNES ON
ITS VOYAGE IN THE ANTARTIC. AN ALBATROSS WAS
ABOARD DESTINED FOR A GERMAN ZOO.
THE DAY AFTER DOCKING IT WAS FOUND
DEAD IN ITS CAGE AND FIFTY
CREWMEN STAGED A STRIKE
AGAINST GOING TO NORWAY.
IN AN INTERVIEW JULY 5TH
THE SHIPS MASTER TOLD
THE DAILY TELEGRAPH IT HAD
TAKEN GREAT COURAGE TO BRING
IT ON BOARD

THE WIND COULD BE A FRIEND OR ENEMY

'A whistling woman and a crowing hen
Are good for neither god nor men.'

LOST LIKE A GLASS ACCIDENTALLY INDICATED A SAILOR WAS TO DROWN
THE RINGING NOTE WAS ASSOCIATED WITH THE TOLLING OF
THE DEATH BELLS SOUNDED AT THE NEWS OF A SHIPWRECK

Full fathom five thy father lies
Of his bones are coral made
Those are pearls that were his eyes
Nothing of him that doth fade
But doth suffer a sea change
Into something rich and strange
Sea nymphs hourly ring his knell
Hark! Now I hear them
DING DONG BELL!

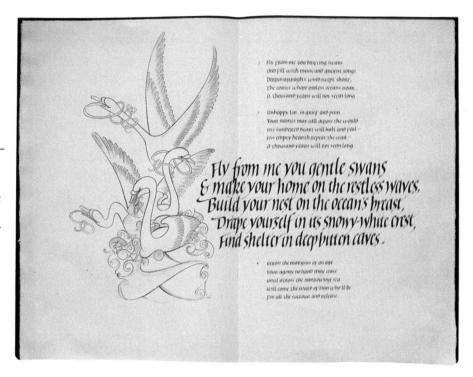

Denis Brown
POEMS FROM THE
CHILDREN OF LIR

*54.5 x 41.5cm
(21 x 16in)
Initial page of manuscript
book. Gouache on
Edmunds Blue handmade
paper.*

Denis Brown
EARLY IRISH
CHRISTIAN POEM

*51 x 52cm
(20 x 20 1/2in)
Written in gouache on
Indian handmade paper,
with gold leaf on gesso and
gum bases.*

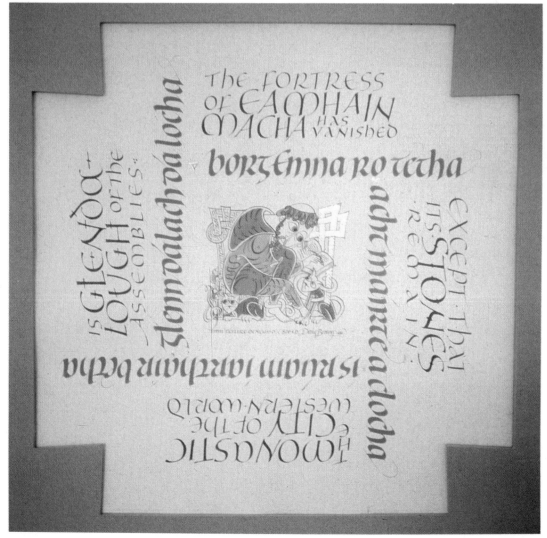

ILLUSTRATING A BOOK

THE first task in a job of this size is to devise a cataloging system capable of handling the sheer volume of references and information. Each of the 47 maps had to contain eight references - a piece of heraldry, two churches, two châteaux, a landscape, a grape type and a vine training method - making a daunting total of nearly 400 pictures.

Accuracy in every detail was paramount. I had to become an expert on the wine-growing areas of the world. In many cases information about these areas had to be taken from one map and combined with cartographic details of another. The spelling of all the names was painstakingly checked and rechecked. The color of the illustrations had to match the source photographs. For the maps themselves, an accurate color coding of the roads, rivers, boundaries, towns and wine areas was obviously essential.

I drew up a form showing where each reference was to be found. An envelope attached to each form proved invaluable for keeping cuttings and loose photocopies relevant to each map.

Adapting the references

The second stage involved adapting the pictures from the source material to the correct scale for use on the map. There was not enough time to redraw each of the pictures, so simplified tracings were made of the buildings, landscapes and vine training methods

BRIEF:

To illustrate a wine guide with 47 decorative maps, each to combine heraldry, architectural references, grape types, landscapes, vine training methods and a map.

TIME LIMIT: Three months, to include picture research and artwork.

SOURCES: Books on wine, architecture and travel, magazines and postcards.

DIMENSIONS: 30 x 45cm (12 x 18in), to be reduced to book dimensions of 157 x 197mm (6 x 8in).

The finished artwork for Burgandy (far right).

A specifically-designed form was essential for keeping track of all the reference material and sources (right).

Burgundy: Auxerrois & Chablis

Vézelay Basilique Ste. Madeleine

Burgundy

St Étienne Auxerre

Grand Crus
Premier Crus
A.C. Chablis
Woodland

Scale in Kilometres

D.C. Hoare

Poinchy

Fye

Ailly Chablis

Serein

Fleys

Chichée

Chardonnay

Château de Tanlay

Chablis Landscape

River Serein At Chablis

directly from the sources. Since the scale of these tracings was often not suitable for the map, the tracings were enlarged or reduced by photocopier in batches. They could then be used at the appropriate size for the map in the finished paste-up rough.

The cartographic details of the maps and the wine areas were redrawn in color from their sources so as to contain only the essential information about roads, rivers, boundaries, towns and wine areas.

The titles were designed so as to use a different style of lettering for maps of different areas of the world: France had italic; Germany, gothic; Italy, Roman Foundational; Eastern Europe, uncials. This helped to define the sections while maintaining the same feel throughout the book. For the roughs the titles were written out in their actual size and in color on layout paper, ready for centering in the paste-up.

Simplified line drawings were adapted from the reference photographs (above left).

The line drawings were the basis for the finished landscapes (above right).

Paste-up roughs

The references were arranged on a sheet of layout paper by eye so that the composition was balanced in weight and the space was filled evenly. The format was portrait, with traditional margins of head 1: sides 1.5: tail 2.

When all the parts had been pasted in place, the sheet was photocopied. Many corrections had been done in the course of checking the information on the maps, so it was easier to trace through a new, single sheet of paper rather than through the paste-up.

The architectural references were traced in a simplified form (right).

The tracings were adjusted to fit each map by photocopying and enlarging or reducing (right).

Artwork

With work for reproduction, it is important to use white paper rather than cream so that the color of the artwork is retained. The artwork here was done by request on an off-white paper, and then reproduced with a white background on white paper. As a result some of the tones of the original paintings were washed out along with the cream tone of the original background. If a cream background is required, it is better to use a cream paper for the book itself. The paper chosen was Heritage, a heavy, acid-free cartridge which did not cockle with the watercolor.

This commission provided a wonderful opportunity to make the most of rich color in the titles, pictures, heraldry and the maps themselves. White pigment was mixed with the colors to make them bright.

Maps were redrawn in color with all the relevant cartographic detail (right).

Italy : Piedmont

Foundational based on Roman lettering was chosen for Italy;

Greece and Cyprus

uncials adapted from Greek Uncial for Eastern European maps;

The Mosel Saar Ruwer Germany

an adaptation of gothic style for Germanic maps;

Burgundy : Auxerrois & Chablis

and a formal italic style in reddish brown for France.

Paste-up rough in color. The small pieces of paper were flattened under a sheet of glass - this makes them less distracting to the eye when assessing the design. The paste up was photocopied for tracing up the finished artwork.

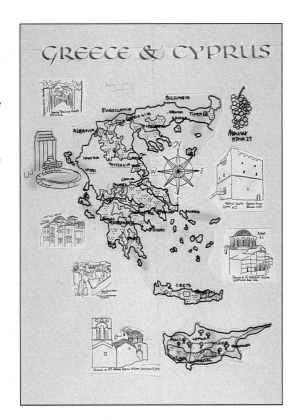

Transfer paper

A piece of tracing paper covered on one side with black lead pencil was used to trace the master copy on to the finished artwork. It is important to clean off surplus graphite from the tracing paper with a cloth. Pressing too hard while tracing leaves marks that are almost impossible to erase and are not always hidden by paint. The tracing paper was held on to the work by masking tape above the top margin of the map.

Tracing

All the lettering of the maps was traced on to the paper. Using a T-square, a line was also ruled for all of these. The title was ruled up and centered on the page and the captions were ruled up and centered under the pictures. After the lettering, the details of the map were traced on, making sure that no lines crossed the lettering, and then the pictures and heraldry.

The same order was used for the color work. The color for each word and each line had to be checked against the colors of the paste-up. All the main titles were completed together. The more lettering that can be done at the same time, the greater the consistency and flow of the writing. The lettering on the map involved using different pens for each color simultaneously. Working from the top left-hand corner across and down the page helps to avoid smudging and to maintain the flow. This method was also used for all the roads, rivers and boundaries.

Texture

The texture of the map relies upon the use of a broad-edged pen to execute the decorative symbols. These can be used to the full to create pattern qualities. Throughout this series of maps the grape and the tree symbols featured prominently as decorative pattern-making textures.

Having completed the map, the illustrations were painted. Wherever possible, the color was checked against the original photograph with the help of the reference form. Blocks of color were applied first in artist-quality watercolor. The details of stone, tile and brick were added when the first paint was dry, with a very fine brush. The landscapes were painted last with flat washes of color to

tie them in with the flat style of the architectural references.

The 47 maps were prepared as finished artwork ready for photographing and printing in the book.

Text and calligraphy by Diana Hoare

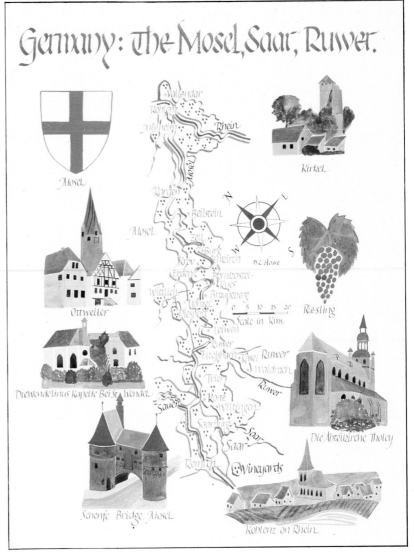

The finished artwork for the Mosel near Ruwer (above), Greece and Cyprus (right), and Italy, Piedmont (far right), ready for the printers - 30 x 45cm (12 x 18in). (By kind permission of Peter Dominic)

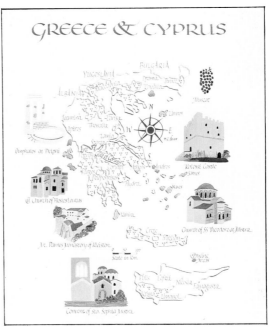

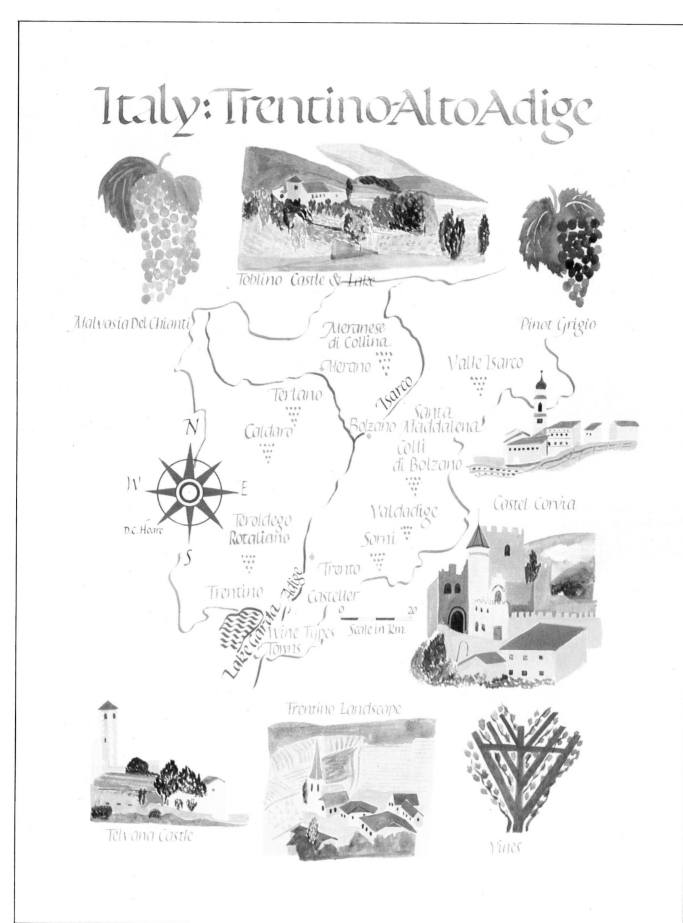

Italy: TrentinoAltoAdige

Toblino Castle & Lake

Malvasia Del Chianti

Pinot Grigio

Meranese
di Collina

Merano

Valle Isarco

Terlano

Isarco

N

Santa
Bolzano Maddalena

Caldaro

Colli
di Bolzano

W E

Castel Corvia

D.C.Hoare

Valdadige

Teroldego
Rotaliano

Somi

S

Trento

Trentino

Castelter

0 20

Lake Garda Adige

Wine Types
Towns

Scale in Km.

Trentino Landscape

Tolvana Castle

Vines

AN ADVERTISING POSTER

THE client had suggested that a ruled white border all around the map would be a good way to display the area of paper without printing on it. However, when the map was drawn to scale, there was an area of white left around the land mass. I felt that this was very interesting in itself and that there was no need to force the map into a stark ruled border.

I decided to allow the parts of France which had no wine areas to bleed off the map, breaking through the white border in places and providing an interesting contrast to the areas of white.

Having established the dimensions of the map itself and its white border, work could begin on the landscapes and architectural references. Although the architecture was taken from photographic sources, the landscape was totally imaginary and pieced together around the main features.

BRIEF:

To produce a full-color poster of a map of France showing wine-growing areas to promote a brand of paper. The wine areas and towns were to be labeled in calligraphy. The map was to be a collage of landscapes and architectural and pictorial references, bottles, grapes and market scenes. A large white border had to be incorporated into the design to show off the quality of the unprinted paper.

TIME LIMIT: Three weeks from start to finish.

SOURCES: Client provided books, magazines and other pictures.

DIMENSIONS: 60 x 90cm (24in x 35in)

Pencil sketch

The rough sketch of the map was begun in pencil. Line drawings of the architectural references were drawn in some detail, but the landscapes were only roughly sketched in

Thumbnail sketches to determine the position of the white border around the map.

The map was designed in detail in pencil and pasted up into a pencil rough. The landscapes are just sketched in at this stage (far right).

A small portion of the map was worked up into a color study to explore ways of blending the architectural and landscape elements, as well as determining the colors (right).

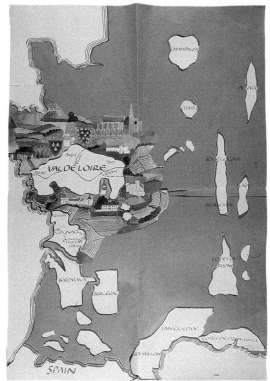

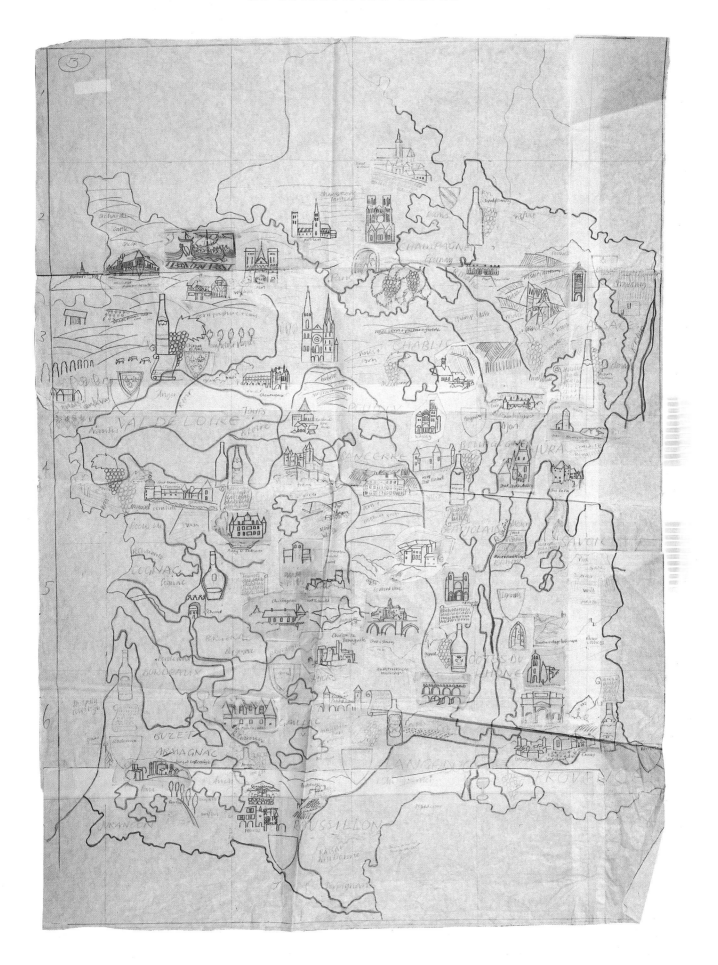

around these. Each pencil study was completed on a separate piece of paper and these were then assembled to make a complete pencil rough.

Color study

The very tight time schedule did not allow for a complete color study of the entire map. However, a limited color study of a small area was carried out to explore the way in which the landscapes blended into one another and fitted around the architecture. In order to evaluate the relative weights of the blank wine areas and the heavier landscape background, the limited color study was pasted up on to dark-green paper. This was to approximate

the color value and density of the landscape background. White paper was pasted up in position to indicate the wine areas and the white border. This gave a fairly good impression of how the map would look when finished.

Artwork

The finished artwork was then traced from the pencil rough using transfer paper and the lettering was ruled up and written out. The detail of the landscapes was painted in as I went along.

Text and calligraphy by Diana Hoare

The white borders of the finished piece show off the quality of the paper advertised (right). (By kind permission of Pollock and Searby Ltd.)

The sea is indicated with a pen line which preserves the thick and thin qualities of the stroke, thus linking with the calligraphy of the wine area labels (below).

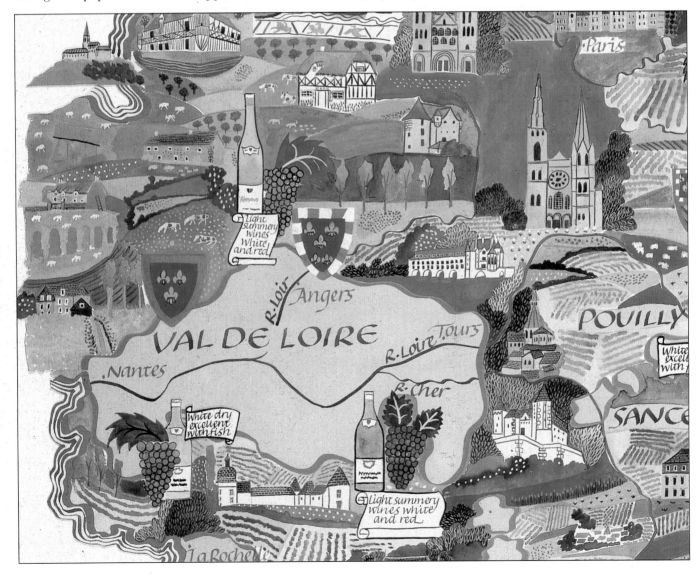

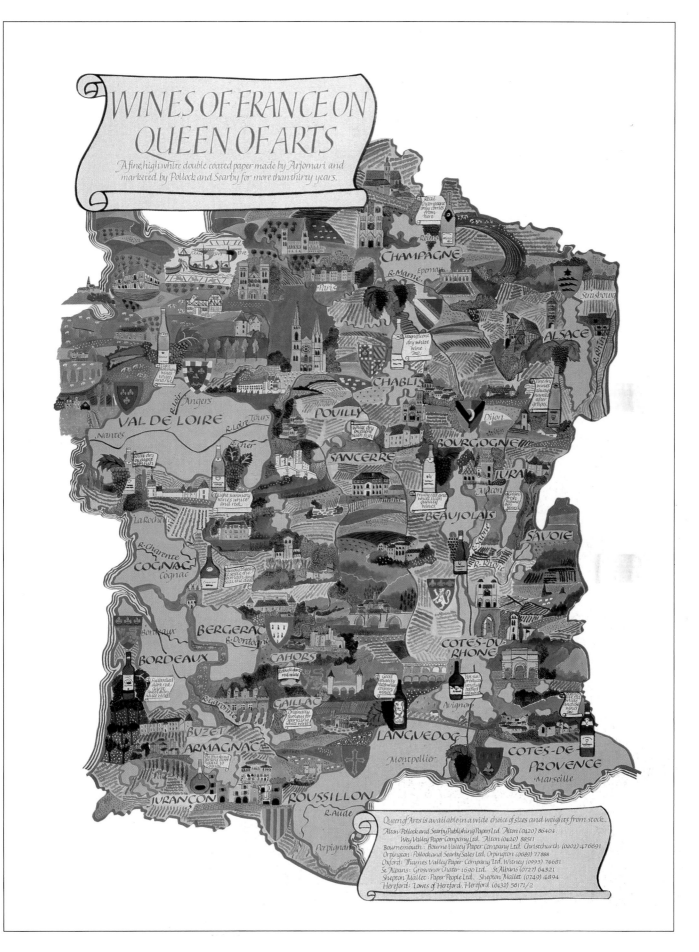

FAMILY TREE

THE size of the family tree was governed by the width of the wall on which it was to hang. The first stage was to plan the size of the lettering. Working on a very small section I lettered out two entries in what I thought would be an appropriate size. From this I was able to calculate whether the entire tree would fit into the available space.

Three nib sizes were used: a Mitchell no. 2 metal roundhand nib with black ink, a no. 4 with black ink and a no. 4 with vermilion watercolor. This last was for the note about partners of the bank.

The lettering was carried out in separate strips, generation by generation. These were then pasted up on to a larger piece of paper with the same amount of space between the generations.

Having established the approximate dimensions of the tree itself, I could decide where to put the title and crest. Owing to the pyramid shape of the tree and the fact that the founding member was to be given some prominence, I did not feel that a banner heading across the top of the composition was suitable. Instead, I decided on a column of lettering in the center with the crest on one side, balanced by the title, golden bottle and address on the other.

The size and weight of the crest acted as a strong counterbalance to the amount of text in the right-hand bottom corner of the tree. The crest itself was drawn from a small embossed design on the cover of a book. The small drawing was enlarged as a pencil sketch to the required size. The rough was assembled on several pieces of layout paper held together with masking tape.

Artwork

Very heavy watercolor paper supplied in a roll was used for this project. In order to work on such a large scale it was necessary to enlarge my drawing board to accommodate the work. The drawing board was 0.9 x 1.2m (3 x 4ft), with a device for ruling parallel lines and a counterweight to help in adjusting the angle of the board. To this I screwed a 1.5 x 1.2m (5 x 4ft) piece of particle board. A shelf was made to hold the roll of paper so that I could reach the top of the sheet.

The parallel ruling facility was invaluable for preparing such a large piece of ruling-up. Once the lines were ruled, the information from the finished rough was transferred in

BRIEF:

To design a large family tree for a banking firm, showing partners and agents in the bank and a large heraldic crest. The design was to include a title and emblem in raised gold.

TIME LIMIT: Six months.

SOURCES: A typed copy, already set out as a family tree, was provided. With a project of this kind, it is essential to have clear, correct copy to work from.

DIMENSIONS: 1.5 x 1.2m (5 x 4ft)

pencil to the final artwork. In this way the information was accurately recorded before work began, thus significantly reducing the chance of mistakes creeping in later on.

Work began by completing the red versal letters of the title. These were executed in vermilion watercolor, with the drawing board at a fairly flat angle to allow the paint to flood into the letter outline without immediately

Amgle of the pen for writing versals.

Shelf added to the end of the drawing board to hold the heavy roll of watercolor paper.

The outline of the versal letters is drawn with a pen and then flooded in with a brush.

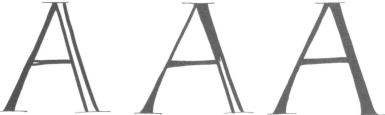

pooling at the base of the strokes. The paint for these letters needs to be of a creamy consistency, thin enough to run through the pen easily, but thick enough to have a good covering quality and to give an opaque appearance to the finished letter.

The letter is constructed with a broad-edged pen held with the nib parallel to the writing line. The two outside strokes are drawn in place and the center is then flooded in with paint from a brush. The letters themselves are based upon the Roman capital letters on Trajan's Column.

Work then began on the individual text entries. The lettering was carried out entry by entry, each one being completed before the next was started.

Corrections

The client wished to alter the information on one entry after this had been completed so a system of making corrections was devised. A small piece of sticky tape was placed over the letter which needed correcting. This was then gently rubbed down with an agate burnisher. Working very carefully but firmly, the tape was snatched upward so that the ink surface of the letter and a little of the underlying paper was brought up with the tape. If any of the ink was left on the paper surface, the process was repeated. The paper was then prepared for writing by lightly burnishing down any loose fibers through a piece of rough paper with the agate burnisher. A dusting of very finely ground gum sanderac can be useful in reconstituting the paper surface and prevents it from bleeding on contact with the ink. The sanderac should be dusted off with a feather in firm strokes.

Painting

The painting of the crest was executed after the lettering had been finished. This was carried out with the board lying more or less flat. When the lettering and painting were completed the lines of descent were drawn in pencil with the ruling device. Then they were ruled in vermilion with a ruling pen and a short perspex ruler. It is very important when using a ruling pen to use the ruler upside down, to prevent the watercolor from running in underneath the edge.

FAMILY TREE
The finished piece was framed and hung (right). (By kind permission of Messrs C. Hoare and Co.).

When using a ruling pen it is instinctive to use the ruler right side up. However, watercolor will seep under the ruler (left top). Always use a perspex ruler upside down. This ensures a neat line with no seepage (left below).

Text and calligraphy by Diana Hoare

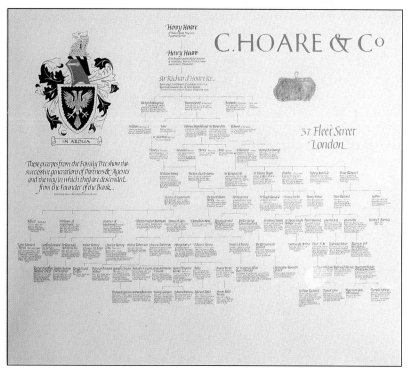

RAISED GILDING

THE final part of the work was the gilding. This was done on a raised gesso ground. The gold sticks to the gesso and is burnished to make it shine. For the gesso you will need: 16 parts slaked plaster; 6 parts white lead; 2 parts centrifugal sugar; 1-1.5 parts glue. The less glue that you can manage to gild with, the brighter the burnish will be, although it is harder to get the gold to stick to the gesso. It is essential to measure very accurately. One good way to do this is to put all the ingredients out separately in little spoonfuls on a sheet of paper so as not to lose count of how many spoonfuls you have taken.

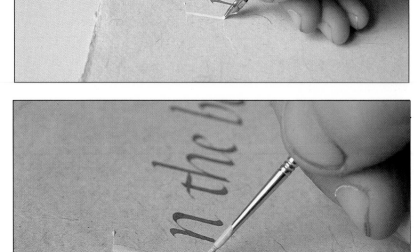

Lay the gesso in outline with a nib. A flexible quill is ideal for this (top).

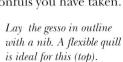

Flood the outline with a brush, so that one area is completely filled with gesso before it is teased on to the next. Make sure you pick up enough gesso to complete the flooding in one go (center).

The gesso should be slightly raised; very high gesso is vulnerable to damage. Do not apply a second coat as different rates of drying will cause cracking. If there is a blemish on the wet gesso, fill with extra gesso; a bump can always be gently scraped away.

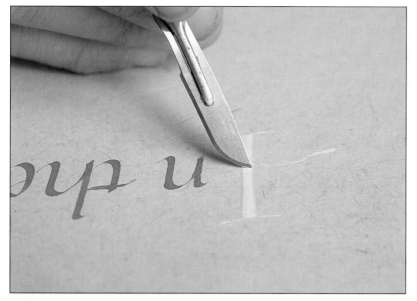

The ingredients should be mixed together and ground on a glass slab with a glass muller. The length of time for which they should be ground varies, but at least half an hour is probably necessary to ensure that everything is thoroughly mixed. It is best to grind without adding extra water. However, the mixture may be very stiff and if so, a few drops of distilled water may be added. When the mixture is thoroughly ground, it is turned out on to silicone-release paper in little cakes. When the cakes are dry, they can be peeled off and wrapped in tissue paper.

To prepare the dry cakes of gesso for use

Scrape gently with a sharp knife until the surface is smooth. The glue tends to rise to the surface when the gesso drys, making it hard for the gold to stick (top).

Rub gently with fine wet and dry paper (center).

Finally, burnish the gesso with an agate burnisher. The smoother the gesso, the shinier the gold will eventually become (bottom).

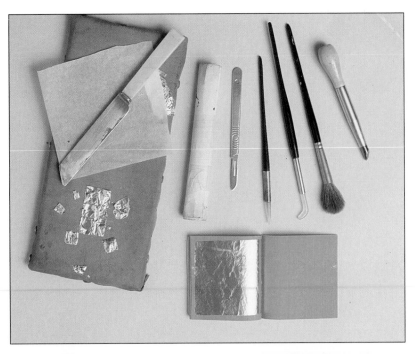

they must be covered with distilled water. First, place the cake into a well such as those on a china palette. Then, cover it with water. Agitate it slightly with a small stick and leave it to soak. Continue the process, adding two or three drops of water at a time and stirring gently. You can also add two drops of thinnish gum ammoniac (see below) at this stage. This will enable you to gild successfully in any atmospheric conditions. When the gesso is more or less thin enough to lay, add three more drops of water and leave them sitting on

To lay the gold you need: a blowing tube of cartridge or stiffish paper fixed with tape; a gilder's cushion; a very sharp knife with 10cm (4in) blade; a Psilomelanite or agate burnisher with a point and flat surface; crystal parchment; a sharp, hard pencil; a book of loose-leaf gold (top).

Lay a sheet of gold directly from the book on to the gilder's cushion. Cut the gold generously, so that the gesso shape is well covered (center).

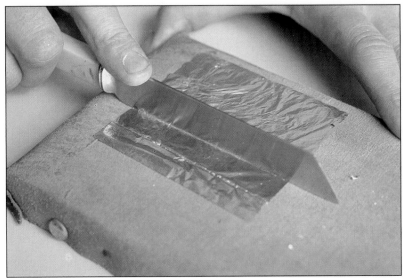

Cut the gold firmly, pressing hard on the cushion, into squares of the required size (bottom).

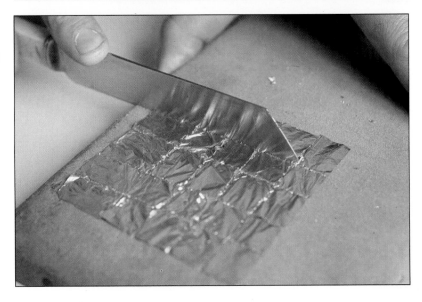

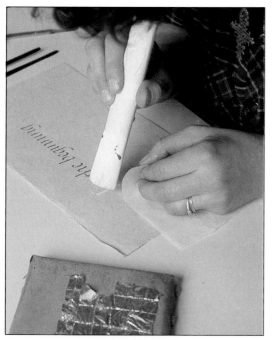

Blow on to the gesso through the tube to moisten it. If you have added gum ammoniac you will not need to blow so hard. Four long breaths should be enough.

the surface of the gesso. Any air bubbles that have got into the mixture will rise to the surface through the water and can then be burst. A few minutes later this is ready for use and you can start laying the gesso.

Flat gilding

The gold lettering in this piece was carried out using gum ammoniac. This can be prepared from the crystal form by soaking the gum crystals in water. After straining, the liq-

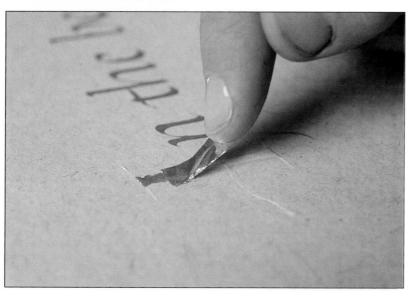

Pick up the gold on your forefinger before you start blowing. Rubbing your nose to pick up some grease first will help it stick. As soon as the gesso is damp, lay the gold over the shape and press down hard with tissue. Rub down with your finger.

Push the gold into the edges of the gesso with a sharp pencil. Work the tip of the burnisher around the shape, pressing the gold into the edges. Burnish the gold through the crystal parchment. Next burnish the surface directly.

uid must then be gently heated in a pan and strained again several times before it is ready to use. It must be thin enough to run through a pen.

As for versals, the drawing board should be at a fairly flat angle for using gum ammoniac in a pen. This prevents the gum from pooling in the base of the letters. When it is dry, the letters can be breathed on gently and the gold laid on to them. For this kind of gilding, it is sometimes easier to use transfer leaf than loose-leaf gold. Transfer leaf is actually attached to sheets of paper in a book and can be very useful when gilding complicated shapes or lines of writing.

Pressing down hard with the flat surface of the burnisher, polish until the gold shines brightly. Use the pointed tip to burnish around the edges. This ensures the gold sticks firmly all around as well as polishing it.

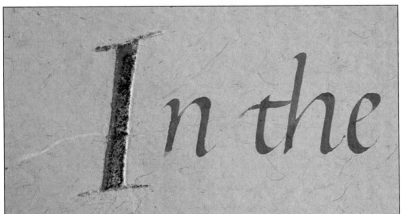

If you need a second layer, lay it on the burnished surface without breathing on it. If there is a hole which needs repairing, remove all loose bits of gold before breathing on it. Lay the second sheet on the first. Press down with tissue paper. Burnish first through crystal parchment then directly.

To decorate a plain gold surface with dots or lines draw the pattern on to crystal parchment and trace through it directly on to the gold with a hard pencil.

Be careful not to pierce the crystal parchment with the pencil and scratch the gold. However, you must press hard enough to indent the surface of the gold and the gesso beneath.

An example of gilded lettering, the outlines add emphasis to the letters.

GILDING

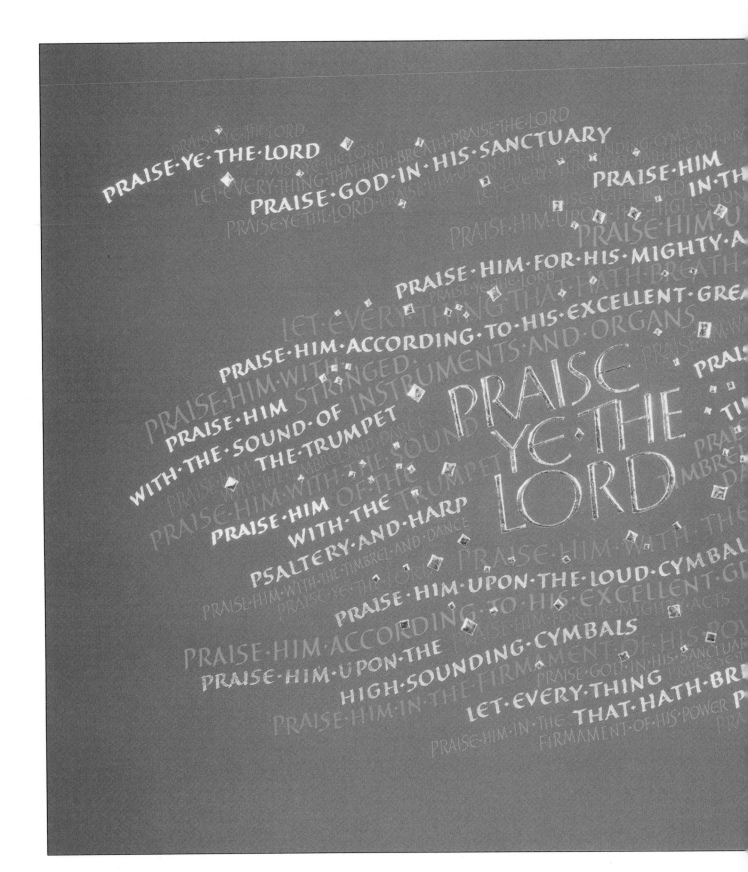

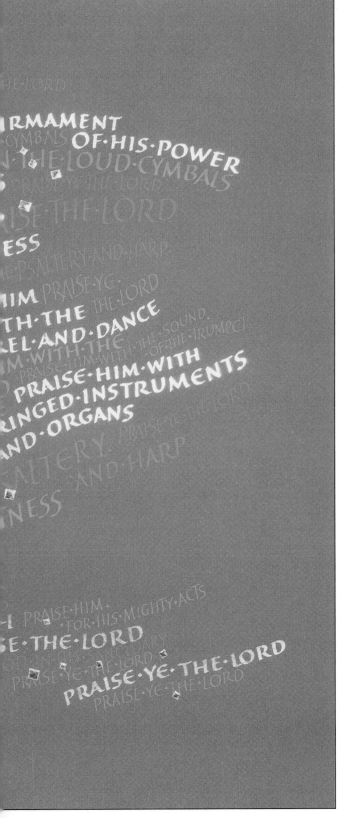

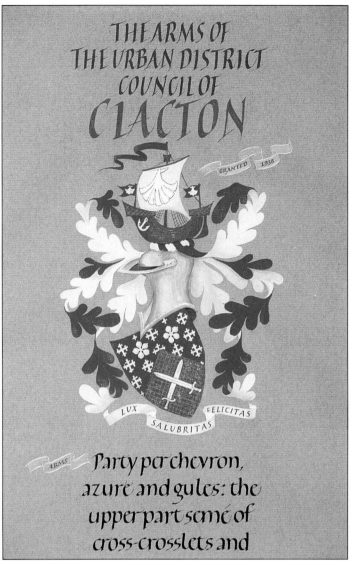

David H. Nicholls
PRAISE YE THE LORD

100 x 72cm (39 x 28in)
Written out in raised and
burnished gold, transfer
gold and gouache, with
quills on BFK Rives
printmaking paper.

Denis Brown
DETAIL OF
HERALDIC PANEL
(CLACTON)

24 x 90cm (91/2 x 35in)
complete
Gouache and bronze
powder on Ingres paper
and a mount covered in
the same paper.

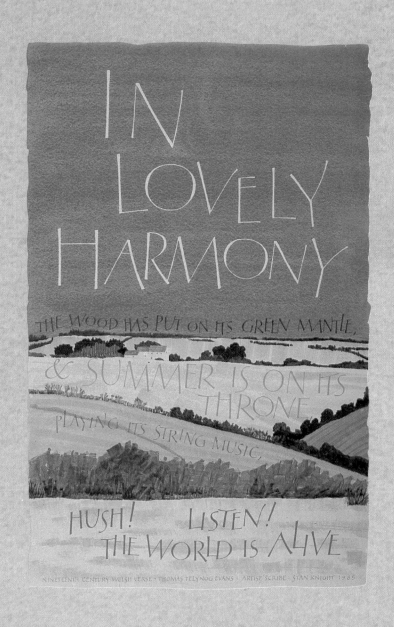

THE SEASONS

THE main inspiration behind *The Seasons* was my interest in mosaics. The composition has a formal, external structure made by the circles and a formal, internal structure made by the mosaic of colored lettering.

I had planned to make a manuscript book in which each section would be devoted to a season and contain poetry from a number of different sources. Each page would reveal a new image. The challenge of a broadsheet, however, is to direct the eye from one piece of poetry to another even though they are on the same page.

The visual effect of the poetry has not been expressed in the lettering, except for an imposed idea of color - warm colors for the hotter months, cold colors for winter. Where it has been explored, as in the trailing pea blooms, this has been principally to assist the movement of the eye across the design rather than to present the image of a pea bloom or a landscape.

External structure

It is easier to begin with a black and white rough. *The Seasons* divides neatly into four parts. I superimposed this overall structure on the mosaic of lettering by placing the names of the seasons in a band at the top and bottom of the design. I chose versals because they

The versal letters are spaced in pencil.

Next the letters are drawn in pencil.

The letters are redrawn in color, slightly widening the letters of spring.

Pasteup color study for the lettering in watercolor.

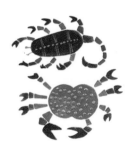

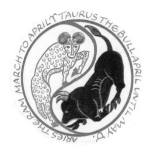

A thumbnail sketch determines the external structure of the design.

The circles are divided by a Yin Yang symbol of life.

Spots of gold link the sun with the planets.

The final representation of the sun was reached after trying out several different versions.

are lively and contrast with the rigidity of the design. Versals are a painted letter style, here executed in watercolor, which links them with the illustration of the astrological signs. Each of the names of the seasons has the same number of letters, but the letters in summer, autumn and winter are wider than those in spring, so they had to be compressed slightly. The bands of versal letters incorporated circles representing the signs of the zodiac, arranged around the central circle of the sun. These signs act as corner stones in a rectangular frame. The structure as a whole is an attempt to impose an intellectual view of the universe upon the words.

In order to include all 12 signs, I used the symbol for life based on the Chinese *Yin* and *Yang* to divide the circles. The style of illustration was taken from medieval bestiaries, in which animals are often contorted into curious shapes. Some of the designs have been made up from spots of color to resemble the texture of a mosaic. The sans-serif capitals around them are also like pieces of mosaic.

To link the star signs and the sun together, the figures were painted and then decorated with little spots of gold: on the claws of the crab, the horns of the ram and the hooves of the bull, for instance. The use of gold in this way can be very effective. The flashing of the light off small areas can be far more exciting than a mirror-smooth slab of gold.

Internal structure

The formality of a mosaic is continued in the internal composition of the piece. Poems written in sans-serif capitals are arranged in narrow columns at either side to complete the rectangular effect. The strip of dense lettering running across the center of the work is very important in the overall structure of the design. It acts both as a dividing and a linking element: the eye is encouraged to follow the line of lettering through the center circle and over to the other side; it is also held by the stillness of the orange, centered lettering beneath the sun, where it is poised on the vertical axis like reflected light.

For each of the seasons I found a quotation which seemed to encapsulate in one sentence the spirit of that season. They make a loud statement that sticks in the mind and give each quarter a block of writing that is large enough to form a good texture.

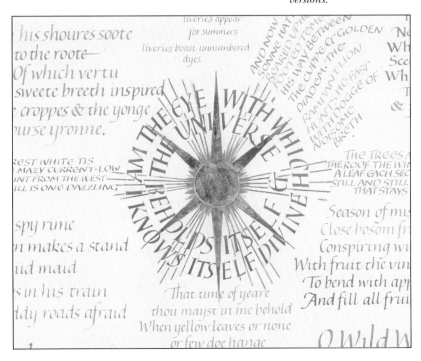

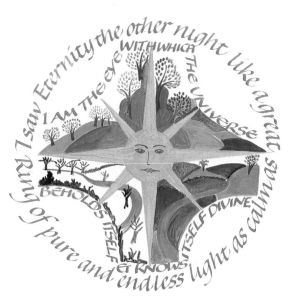

The first version of the sun was surrounded by seasonal landscapes (above).

The next stage was to convey a sense of the cyclical movement of the seasons. The zodiac moves through the sky as the year slowly passes. Visually this sense of movement was already emphasized through the division of each of the zodiac circles. The repetition of the Yin and Yang symbols of life gives a feeling of spinning movement to the rest of the page.

Roughs

I made several color roughs for this piece. The eye is led around the design by the use of slowly changing colors. This echoes feelings of changing temperature and nature's progress throughout the year. The outside borders of the piece also reflect these color changes. The colors of the versals and the zodiac symbols summarize the colors used in the rest of the lettering of that season, while in their weight and size, they contrast with it.

The mosaic of words was given cyclical movement by extending the curved lines of "and now the sonne hath reared up his fyrie head". These letters are like flames shooting out of the sun. The lettering is attempting to illustrate the meaning of the text and at the same time give a feeling of movement to the composition as a whole. The rigid structure was also relaxed by interweaving the lettering in the spring and summer panels and making them more energetic. "Tossing his mane" and "the juicy wheat" were given flourishes.

The sun

The symbol of the sun is the focal point of the composition. As the center of the mosaic it is static. Contained within the stillness, however, there is considerable energy. Visually, the sun as the blazing center of the universe is a potent image. And in the words used, the sun is seen as the center and source of all spirititual life. The quotation gives the sun a Godlike,

A full color paste up entailed compositional changes and provided an opportunity to check all the wording.

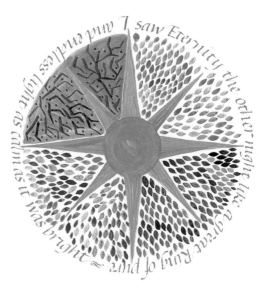

The second version of the sun was stylized, set against a textured background.

all-seeing quality: "I am the eye with which the universe beholds itself and knows itself divine", from Shelley's "Hymn to Apollo". This is a good example of how effective lettering, used in conjunction with a symbol, can be when the poetry itself is so strong.

My first idea had been to combine the lettering with illustration and to place a stylized face in the center of the gold on the sun. In four quarters around this I planned to portray a different landscape, one for each of the four seasons. This developed into a stylized sun set against a textured background of leaves and branches reflecting seasonal changes. Neither of these versions really worked. They were too realistic in their illustration and the use of ital-

ic lettering around the central circle seemed far too bland for the meaning of the words.

The idea of the sun's rays bursting through the compressed versal letters seemed to work as an abstract representation of the words. The energy of the idea was reflected in the energy of the letter forms. The broken texture of the versals made them like pieces of mosaic.

The horizontal points of the sun were omitted as there was already a strong horizontal line across the center. The emphasis on the vertical is also made with the rays. The energy of the sunburst is made by the gold lines, which break through the rings of capital letters and explode into the main body of the text.

Gilding

The gold in the central design was both raised and flat. The circle in the middle of the sun was raised gold and burnished quite highly. The large gold rays and the thin gold lines of the sunburst, and the gold features of the figures were all executed in flat gilding with gum ammoniac. (For the recipes and methods of preparation for raised and flat gilding, see Family Tree.)

The raised gesso for the sun was laid first. The outside shape of the large rays was painted in with a narrow brush using gum ammoniac, which was then flooded into the outline with a larger brush. The surface of the gum should be slightly raised. It should be flooded in very smoothly, with no dimples or uneven areas. The gilding of the zodiac figures was also done with gum ammoniac laid by brush. Although gum ammoniac may be lightly burnished after it is dry and before the gold is put down, this must be done through a piece of crystal parchment. If you were to use the burnisher directly on the gum itself, it might very easily be dented or damaged. Once the gold is laid on the gum, the heat made by the burnisher's rubbing on it might easily damage the gold surface. This problem with friction means that gold laid on gum ammoniac can never be burnished very highly.

The thin rays of the sunburst were ruled in gum ammoniac with a ruling pen. This should be done with a perspex ruler which is used upside down to prevent the gum from running in under the ruler.

The gilding of such narrow rays is best done with transfer not loose-leaf gold. You can make transfer gold from loose-leaf gold by rubbing a leaf of tissue paper with a candle. Enough candle wax is left on the tissue to make the gold stick to the paper.

Text and calligraphy by Diana Hoare

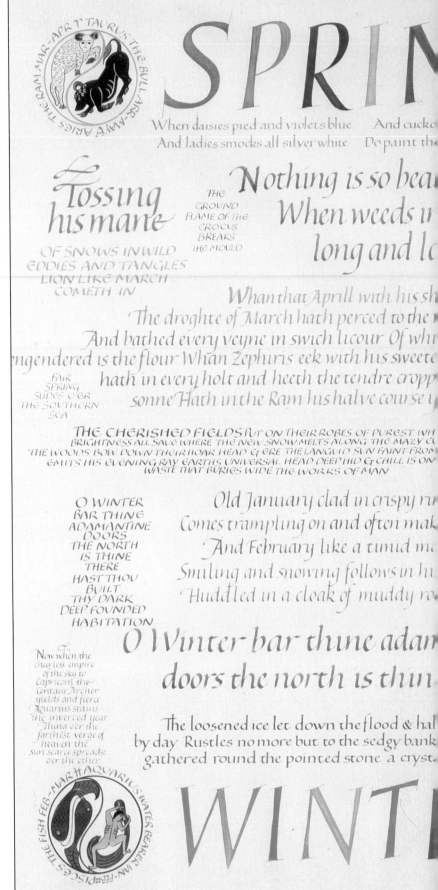

SEASONS
106 x 76cm (42 x 30in).
The composition is
inspired by mosaics.

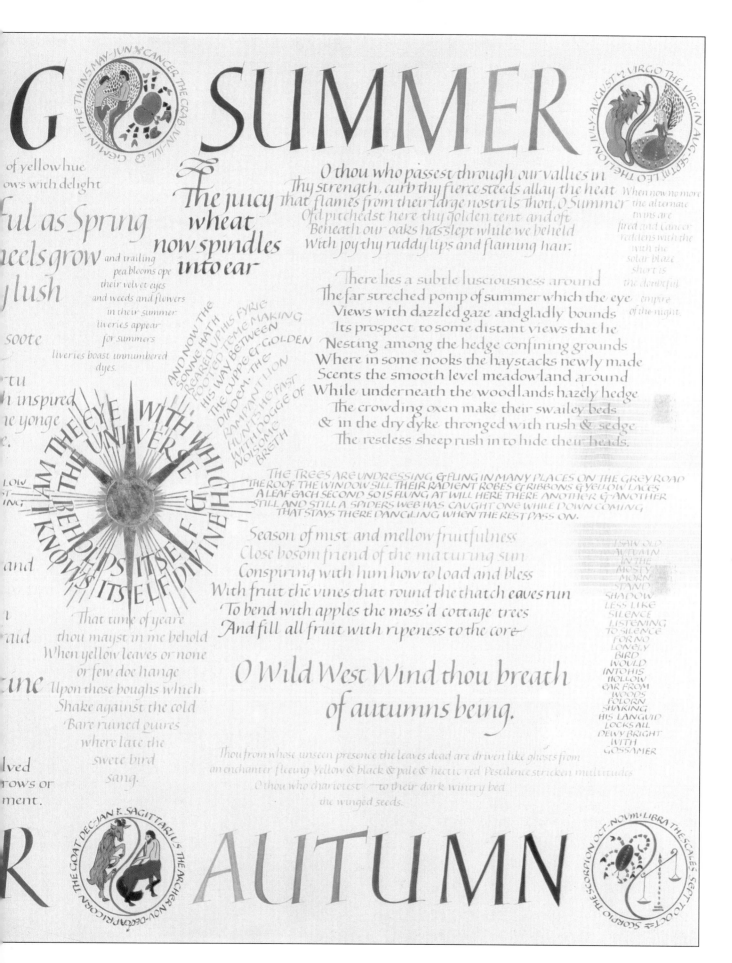

G SUMMER

GEMINI THE TWINS MAY-JUN ✳ CANCER THE CRAB JUN-JUL

JULY-AUGUST ✳ VIRGO THE VIRGIN AUG-SEPT ✳ LEO THE LION

of yellow hue
ows with delight

ful as Spring

eels grow

lush

soote

rtu

n inspired
e yonge
.

ow
st
ing

and

aud

une

lved
rows or
ment.

The juicy wheat now spindles into ear

and trailing pea blooms ope their velvet eyes and weeds and flowers in their summer liveries appear for summers liveries boast unnumbered dyes.

O thou who passest through our vallies in
Thy strength, curb thy fierce steeds allay the heat
that flames from their large nostrils thou, O Summer
Oft pitchedst here thy golden tent and oft
Beneath our oaks hast slept while we beheld
With joy thy ruddy lips and flaming hair.

There lies a subtle lusciousness around
The far streched pomp of summer which the eye
Views with dazzled gaze and gladly bounds
Its prospect to some distant views that lie
Nesting among the hedge confining grounds
Where in some nooks the haystacks newly made
Scents the smooth level meadowland around
While underneath the woodlands hazely hedge
The crowding oxen make their swailey beds
& in the dry dyke thronged with rush & sedge
The restless sheep rush in to hide their heads.

AND NOW THE SONNE HATH REARED UP HIS FYRIE FOOTED TEME MAKING HIS WAY BETWEEN THE CUPPE & GOLDEN DIADEM. THE RAMPANT LION HUNTS HE FAST WITH DOGGE OF NOISOME BRETH

When now no more the alternate tvvins are fired and Cancer reddens with the with the solar blaze. Short is the doubtful empire of the night.

I AM THE EYE WITH WHICH THE UNIVERSE BEHOLDS ITSELF & KNOWS ITSELF DIVINE

THE TREES ARE UNDRESSING & FLING IN MANY PLACES ON THE GREY ROAD THE ROOF THE WINDOW SILL THEIR RADIENT ROBES & RIBBONS & YELLOW LACES A LEAF EACH SECOND SO IS FLUNG AT WILL HERE THERE ANOTHER & ANOTHER STILL AND STILL A SPIDERS WEB HAS CAUGHT ONE WHILE DOWN COMING THAT STAYS THERE DANGLING WHEN THE REST PASS ON.

Season of mist and mellow fruitfulness
Close bosom friend of the maturing sun
Conspiring with him how to load and bless
With fruit the vines that round the thatch eaves run
To bend with apples the moss'd cottage trees
And fill all fruit with ripeness to the core

That time of yeare
thou mayst in me behold
When yellow leaves or none
or few doe hange
Upon those boughs which
Shake against the cold
Bare ruind quires
where late the
swete bird
sang.

O Wild West Wind thou breath
of autumns being.

I SAW OLD AUTUMN IN THE MISTY MORN STAND SHADOW LESS LIKE SILENCE LISTENING TO SILENCE FOR NO LONELY BIRD WOULD INTO HIS HOLLOW EAR FROM WOODS FOLORN SHAKING HIS LANGUID LOCKS ALL DEWY BRIGHT WITH GOSSAMER

Thou from whose unseen presence the leaves dead are driven like ghosts from
an enchanter fleeing Yellow & black & pale & hectic red Pestilence stricken multitudes
O thou who chariotest —— to their dark wintry bed
the winged seeds.

R AUTUMN

CAPRICORN THE GOAT DEC-JAN F. SAGITTARIUS THE ARCHER NOV-DECEMBER

OCT-NOV ✳ LIBRA THE SCALES SEPT TO OCT ✳ SCORPIO THE SCORPION

A CALENDAR

A FEW months before beginning this piece I had been to the British Museum, London and made drawings of several artifacts, not knowing when or how I would use them. One object was an Anglo-Saxon brooch consisting of several smaller circles set around a central one. The design seemed eminently suitable as a basis for this particular project.

The text I chose was from Thomas Hardy, whose work includes pieces on woodlands and seasonal occupations such as cider-making and tree-planting. Having decided upon the design and the text, I began to work on a black and white sketch of the calligraphy. The next step was a pencil rough which established the exact position of each element. Seeing the design in black and white rather than color helps you to look at it as an abstract pattern, and thus to decide whether all the various elements are working together.

The first color rough was executed on cream-colored paper. It is very important when using subtly graded watercolor to work on a white background, otherwise the colors tend to appear muddy.

The outer rim of the wheel was designed in red. The main color of the piece was green and the eye cries out for the complementary color of red to relieve it. The red band is broken with the little green zodiac signs, which relate it to the green center of the composition.

The design at the center of the piece was taken from a book of signs by Rudolph Koch and is thought to represent the eight points of the heavens. I thought that this emphasized the intention of the calendar while providing an interesting centerpiece to the design.

The finished piece was very carefully ruled up. When each line was in position, the lettering was penciled in. This is the only way to ensure that no mistakes work their way into such large and complex pieces of work. The pencil should be used very lightly to prevent the lines from showing under the watercolor paint. When the lettering is complete and the paint is dry, the writing lines can be removed carefully with an eraser.

Text and calligraphy by Diana Hoare

Basic design questions are best resolved in an initial, rough, black and white sketch.

The next step is a detailed pencil rough. The initial design has been modified; the large capitals in the center unify the design (right).

A color rough was only begun when every detail of the overall design had been decided (below).

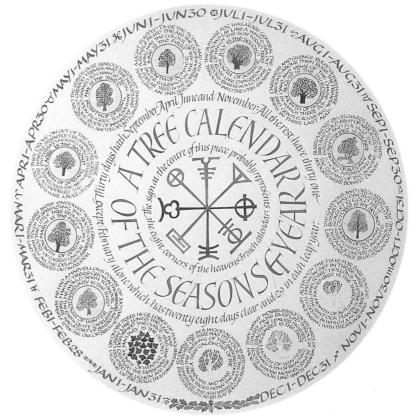

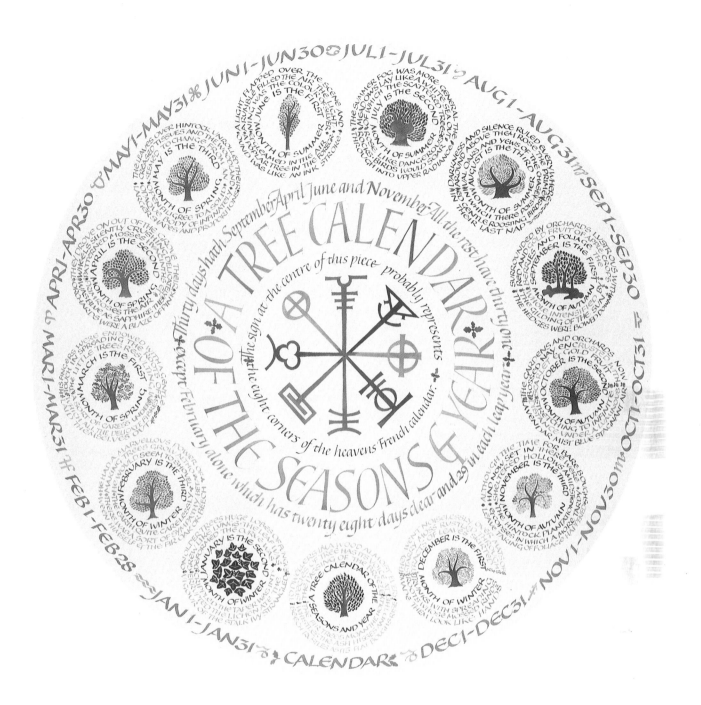

A CALENDAR
76 x 76cm (30 x 30in)
The white paper makes the
colors sparkle. Greens are
light and yellow-based;
darker, blue-greens tended
to deaden the overall effect
(above).

Detail showing how the
leaves have been painted
with thick watercolor to
give an opaque effect.
Adding a little white to the
paint increases the
opaqueness.

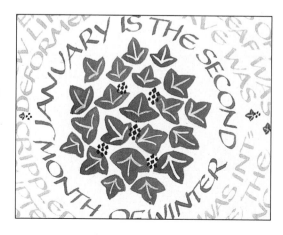

HEDGEROWS

THE possibilities for using calligraphy as a propaganda weapon or as a medium for conveying facts are very exciting. With this piece I was initially captivated by the startling fact that every year nearly 8,000km (5,000 miles) of hedgerow in Britain are lost through changes in farming practices. I began to work on ideas for a design in which such a dramatic statement about the destruction of the country landscape could feature prominently. I collected further information about the history of hedges, their function as a habitat for fauna and flora, and the methods of cutting and laying or pleaching hedges. I also used two John Clare poems and a passage from Thomas Hardy.

Lettering is about the creation of textures. For this piece I was inspired by the textures of the landscape outside my workshop window. There are sweeping views across fields and hedges to a distant range of hills. The different fields - corn, stubble, red ploughed earth, grass, root crops, hops - and orchards provide numerous different colors and textures, which change constantly as sunlight and cloud play across them.

Tree textures also played an important part in my mind: bare branches against a gray sky, trees in full summer foliage, autumn

Inspiration was drawn from the nature around me, such as the strong architectural shapes of tree trunks and branches silhouetted against the sky (right and below).

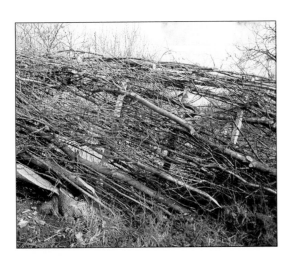

The texture of cut and laid hedges - a traditional method of managing hedges in England - inspired the texture of the words (left).

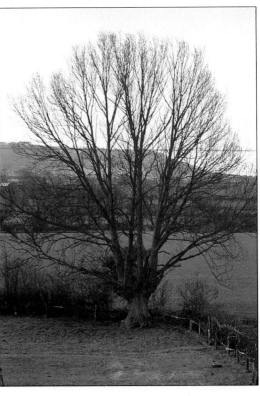

HEDGEROWS

Hedge species include Elder, Hazel, Quickthorn or Whitethorn, Ash, Elm, Oak, Willow, Beech, Blackthorn, Alder

MANY HEDGES BY AND LARGE DATE FROM THE ENCLOSURE ACTS WHICH BEGAN DURING THE REIGN OF GEORGE II IN THE EIGHTEENTH CENTURY. TEN THOUSAND SQUARE MILES OF UNTILLED LAND WERE RECLAIMED FROM FOREST, MOORLAND AND FEN DURING THIS TIME AND ENCLOSED OFTEN WITH HEDGES

Underneath the woodlands hazly hedge
The crowding oxen make their swaily beds

And in the dry dyke thronged
with thorn and hedge

The restless sheep rush in to hide their heads
From the unloved and ever-haunting flue.

HEDGES CONTAIN CLIMBING PLANTS SUCH AS HONEYSUCKLE OLD MANS BEARD BRIONY BRAMBLE WILD HOP IVY DOG ROSE· FLOWERS SUCH AS VIOLETS PRIMROSE COWSLIP & FOXGLOVE RELY ON HEDGES TO SURVIVE WHEN INTENSIVE MODERN FARMING METHODS HAVE DRIVEN THEM FROM THE OPEN GROUND· HEDGEROWS PROVIDE A HABITAT FOR BIRDS SUCH AS ROBIN WREN CHAFFINCH THRUSH YELLOWHAMMER LINNET MAGPIE WOOD PIGEON AND ANIMALS SUCH AS HEDGEHOG STOAT WEASEL RATS MICE RABBITS HEDGES PROVIDE BOTH A PALATABLE SOURCE OF NUTRITION RICH IN MINERALS FOR CATTLE AND SHEEP AND SHELTER FROM FLIES AND WEATHER THEY PROTECT THE LAND FROM EROSION BY THE WIND AND RAIN

HE WENT ALONG THROUGH THE GORGEOUS AUTUMN LANDSCAPE OF WHITE HART VALE SURROUNDED BY ORCHARDS LUSTROUS WITH THE REDS OF APPLE CROPS BERRIES & FOLIAGE THE WHOLE INTENSIFIED BY THE GILDING OF THE DECLINING SUN· THE EARTH THIS YEAR HAD BEEN PRODIGALLY BOUNTIFUL AND NOW WAS THE SUPREME MOMENT OF HER BOUNTY· IN THE POOREST SPOTS THE HEDGES WERE BOWED WITH HAWS AND BLACK BERRIES· ACORNS CRACKEL UNDERFOOT AND BURST HUSKS OF CHESTNUTS LAY EXPOSING THEIR AUBURN CONTENTS AS IF ARRANGED BY ANXIOUS SELLERS IN A FRUIT MARKET

A HEDGE MARKS A BOUNDARY AND IS TO KEEP ANIMALS IN· THESE ARE ITS PRIMARY FUNCTIONS· BY CUTTING AND LAYING ITS STOCK PROOF QUALITIES ARE MAINTAINED· IN EIGHT TO TEN YEARS AN UNTRIMMED HEDGE GETS THIN AND DIES IN THE BOTTOM AND IS NO LONGER STOCK PROOF· A TALL HEDGE OF TWENTY FEET HAS OTHER FUNCTIONS· WELL AS A CAN ALSO PROVIDE WINDBREAK FOR HOPS AND APPLETREES

Fringing the forests devious edge
Half robed appears the
hawthorn hedge

Or to the distant eye displays
Weakly green, its budding
sprays

TO MAINTAIN A HEDGE AS A STOCK PROOF BOUNDARY CUTTING & LAYING OR PLEACHING· IS CARRIED OUT· THIS IS ACHIEVED BY CUTTING SOME CHOICE VERTICAL GROWTH FROM THREE QUARTERS TO SEVEN EIGHTHS THROUGH· THESE ARE THEN BENT OVER AND HELD IN POSITION WITH STAKES MADE FROM WILLOW BIRCH HAZEL CHESTNUT OR ANY STRAIGHT WOOD· ONCE LAID A HEDGE FORMS A HURDLE OF LIVE GROWING WOOD SENDING VERTICAL GROWTH FROM THE ANGLED PLEACHERS AS WELL AS FROM THE TRIMMED STUMPS

Five thousand miles of hedgerow have been lost every year through modern arable practises. Overproduction has resulted in a return to more balanced farming where the hedgerow plays its traditional part.

But over
production spells a return
will bring back a

Gradually more balanced farming methods are returning

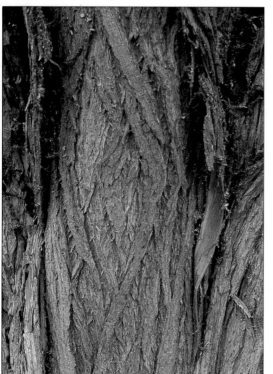

The paste up rough allowed for checking the wording and adjusting the design (above).

The texture and color of bark and stones contributed to the overall effect of the finished piece (left and right).

leaves against a bright-blue sky, or the architectural strength of a tree trunk; even the texture of bark, fallen leaves on the grass, apple trees smothered with blossom or encrusted with golden and red fruit.

The arrangement of the lettering follows the lines of a fairly traditional layout, although there is variety and movement within the design itself. The title is echoed by the important quotation across the foot of the broadsheet, which gives it some prominence. The blocks of information about hedges have a tight, interlinking texture which is reminiscent of the interwoven branches of the cut and laid hedge. The lettering is executed in watercolor which blends and changes throughout, so that no two letters are the same color. This gives a harmonious feel to the coloring of the piece.

Text and calligraphy by Diana Hoare

HED

Hedge species include Elder, Haz

MANY HEDGES DATE FROM THE ENCLOSURE ACTS WHICH BEGAN DURING THE REIGN OF GEORGE II IN THE EIGHTEENTH CENTURY. TEN THOUSAND SQU MILES OF VNTILLED LAND WERE RECLAIMED FRO FOREST, MOORLAND AND FEN DURING THIS TIME AN ENCLOSED WITH HEDGES

Underneath the woodlands hazely hedg
The crowding oxen make their swaily be
And in the dry dyke thronged
with rush and sedge
The restless sheep rush in and
hide their heads
From the unlost & ever haunting flie

HEDGES CONTAIN CLIMBING PLANTS SUCH AS HONEYSUCKLE OLD MANS BEARD BRIONY BRAME WILD HOPS IVY DOGROSE · FLOWERS SVCH AS VIO PRIMROSE COWSLIP AND FOXGLOVE RELY ON HED TO SVRVIVE WHEN MODERN INTENSIVE FARMIN METHODS HAVE DRIVEN THEM FROM THE OPEN C HEDGEROWS PROVIDE A HABITAT FOR BIRDS SVCH A ROBIN WREN CHAFFINCH YELLOW HAMMER THR LINNET MAGPIE WOODPIGEON AND ANIMALS SVC HEDGEHOG STOAT WEASLE RAT MOUSE AND RA HEDGES PROVIDE BOTH SHELTER FROM WEATH AND FLIES AND A PALATABLE SOVRCE OF NVTRIT RICH IN MINERALS FOR CATTLE AND SHEEP TH PROTECT THE LAND FROM EROSION BY THE W AND RAIN

Five thousand miles of hedgerow have
more balanced farming methods are

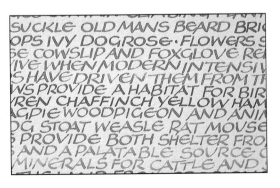

Lettering inspired by the texture of the cut and laid hedge (left).

GEROWS

Quickthorn, Ash, Elm, Oak, Willow, Beech, Alder, Holly.

WENT ALONG THROUGH THE GORGEOUS AUTUMN LANDSCAPE OF WHITE HART VALE SURROUNDED BY ORCHARDS LUSTROUS WITH THE REDS OF APPLE CROPS BERRIES AND FOLIAGE THE WHOLE INTENSIFIED BY THE GILDING OF THE DECLINING SUN · THE EARTH THIS YEAR HAD BEEN PRODIGALLY BOUNTIFUL & NOW WAS THE SUPREME MOMENT OF HER BOUNTY · IN THE POOREST SPOTS HEDGES WERE BOWED WITH HAWS AND BLACKBERRIES ACORNS CRACKED UNDERFOOT & BURST HUSKS OF CHESTNUTS LAY EXPOSING THEIR AUBURN CONTENTS AS IF ARRANGED BY ANXIOUS SELLERS IN A FRUIT MARKET

A HEDGE MARKS A BOUNDARY AND IS TO KEEP ANIMALS IN · THESE ARE ITS PRIMARY FUNCTIONS · BY CUTTING AND LAYING ITS STOCKPROOF QUALITIES ARE MAINTAINED · IN EIGHT TO TEN YEARS AN UNTRIMMED HEDGE GETS THIN IN THE BOTTOM AND DIES AND IS NO LONGER STOCKPROOF · A TALL HEDGE OF TEN OR TWENTY FEET CAN ALSO PROVIDE A WINDBREAK FOR HOPS OR APPLES ·

Fringing the forests devious edge
Half robed appears the
hawthorn hedge
Or to the distant eye displays
Weakly green its budding
sprays.

TO MAINTAIN A HEDGE AS A STOCKPROOF BOUNDARY CUTTING AND LAYING IS CARRIED OUT · THIS IS ACHIEVED BY CUTTING SOME CHOICE VERTICAL GROWTH FROM THREE QUARTERS TO SEVEN EIGHTHS THROUGH · THESE ARE THEN BENT OVER AND HELD IN POSITION WITH STAKES MADE OF WILLOW BIRCH HAZEL CHESTNUT OR ANY STRAIGHT WOOD · ONCE LAID A HEDGE FORMS A HURDLE OF LIVE GROWING WOOD SENDING VERTICAL GROWTH FROM THE ANGLED PLEACHERS AS WELL AS FROM THE TRIMMED STUMPS ·

lost every year through modern arable practises but gradually ming where hedgerows play their traditional part. ℍ scripsit.

HEDGEROWS
52 x 80cm
(201/2 x311/2in) The
arrangement of the lettering
is traditional, but the design
conveys the variety and
movement of the landscape.

OAK AND ASH

WHERE lettering is to be accompanied by illustrations, there obviously has to be a relationship between the lettering and the style of illustration. However the calligrapher can bring words to life by illustrating their meaning with lettering alone. This opens endless avenues for exploration.

Oak and Ash is an attempt to portray a wood through lettering. The piece was inspired by woods in Dorset, England. Instead of illustrating the poems which describe the wooded landscapes, I have used the color and shape of the letters in the tree names to suggest trees, and also used color and texture in the writing of the poetry to suggest some of the landscapes portrayed in the words.

First, looking into this imaginary wood, the eye can focus on the tree names as if they were trees in the foreground with the poetry as background. When seen as background to the trees, the poetry has many textures. It can

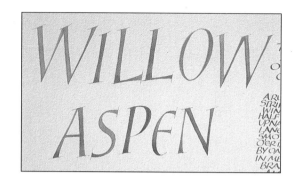

Detail of tree names representing trees in the foreground (right).

Woodland scenes which inspired this piece of calligraphy.

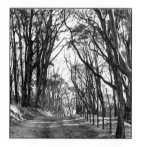
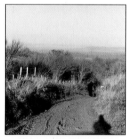
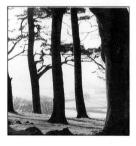
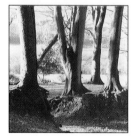

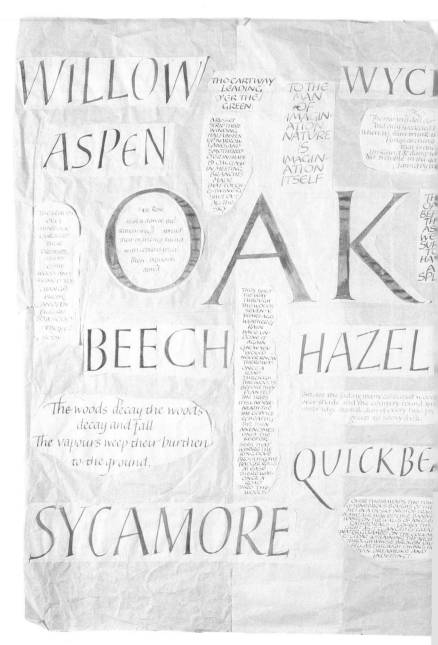

The rough color paste-up allowed for refinement of the design and checking that the words were correct (below).

Detail suggesting undergrowth, leaf canopy and woodland floor textures (left).

resemble undergrowth, leaf canopy and the woodland floor. Alternatively, one can look past the tree names, deeper into the poetry, to explore a variety of different woodland landscapes. When seen this way, the lettering of the poetry portrays different landscapes, such as a group of pine trees, a pathway or distant wooded hills seen beyond the wood itself.

In the design, by placing the tree names and poems evenly around the broadsheet the reader's eye is allowed to wander freely. I am trying to express the feeling of walking at will through a wood. The viewer is led on from passage to passage to inquire further into the piece.

Rather than leave a white hole inside the letter "O" of Oak, a small, light-textured piece in italic was chosen to fill the gap. The overall quality of the letter form, which lies in its strength, size and beauty, is kept. The con-

Detail of poetry - the content of the words presents changing vistas and views to the imagination (below).

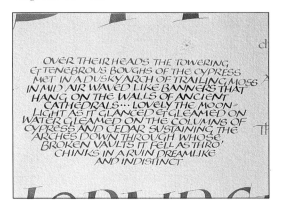

ASH

trast of textures which characterizes the rest of the design is carried into the open texture of the letters.

Although the white space on the broadsheet is filled evenly, the eye is led first to the large letters of "Oak" and "Ash" which form the title. The style of the lettering of these words was designed to reflect something of the qualities of the trees themselves. The broad, ancient oaks are like the large, classically strong Roman letters which depict them. Originally, these Roman letters were designed and executed with a chisel-edged brush. However, once you understand how the letter forms originated, they can be drawn with a pencil and then painted, using different colors. The word "Ash" was the second element to be designed. This is a less substantial tree, one which always gives a sense of rushing movement when the wind blows through its leaves. These versal letters are based on the Roman letter forms, but they have been adapted to be written more freely. The shape of the letters is slightly reminiscent of ash twigs.

The use of color in the piece is two-fold. Each of the larger letters has been painted in several shades of one color, but within the blocks of lettering as a whole there is considerable movement of color.

Text and calligraphy by Diana Hoare.

Versals give a sense of movement, reflecting some of the qualities of the ash tree (above).

OAK AND ASH
106 x 76cm (43 x 30in)
The color and shape of the lettering combine with the texture of the design to convey the atmosphere of a wood (right).

The large Roman letters reflect the qualities of the oak tree (below).

OAK

WILLOW
ASPEN

THE LEAVES
OVER
HINTOCK
UNROLLED
THEIR
CREASED
TISSUES
& THE
WOODLANDS
SEEMED TO
CHANGE
FROM
AN OPEN
FILIGREE
TO A
SOLID
OPAQUE
BODY

last rose as in a dance the stately trees & spread their branches hung with copious fruit their blossoms gemmed.

MY ASPENS
DEAR WHOSE
AIRY
CAGES
QUELLED
QUELLED
OR QUENCHED
IN LEAVES THE
LEAPING SUN

O
OA
BEECH

The woods decay the woods decay and fall
The vapours weep their burthen to the ground

SYCAMO

Detail of poetry representing background to the trees (right).

HAZEL

But see the fading many coloured woods Shade deepening over shade and the country round um-brown a crowding umbrage dusk and dun of every hue from wan declining green to sooty dark.

WYCHELM

The roaring dell o'er wooded narrow deep
And only speckled by the midday sun
Where its slim trunk the ash from rock to rock
Flings arching like a bridge;
that branchless ash
Unsunned and damp whose few poor leaves
Ne'er tremble in the gale yet trembles still
Fanned by the waterfall.

TO THE MAN OF IMAGIN ATION NATURE IS IMAGIN ATION ITSELF

How Pleasant

NEATH THE WILLOW BY THE BROOK THATS KEPT ITS ANCIENT PLACE FOR MANY A YEAR TO SIT AND O'ER THE CROWDED FIELDS TO LOOK & THE SOFT DROPPING OF THE SHOWER TO HEAR OURSELVES SO SHELTERED

LARCH

As when upon a tranced summer-night
Those green robed Senators of ancient woods
Tall oaks branch charmed by
ernest stars dream.

THE POPLARS ARE FELLED FAREWELL TO THE SHADE AND THE WHISPERING SOUND OF THE COOL COLONNADE

SILVER BIRCH

THE OAK BEFORE THE ASH WE'RE SURE TO HAVE A SPLASH

THE ASH BEFORE THE OAK WE'RE SURE TO HAVE A SOAK

I stood on Brockans sovran height and saw
woods over woods, hills over hills
A surging scene only limited
By the blue distance

AND HERE WERE FORESTS AS ANCIENT AS THE HILLS EN FOLD ING SUNNY SPOTS OF GREENERY

HAZEL

ASH

But see the fading many coloured woods Shade deepening over shade and the country round um-brown a crowding umbrage dusk and dun of every hue from wan declining green to sooty dark.

Here waving groves a chequered scene—display And part exclude and part admit the day There interspersed with lawns & opening glides.

OVER THEIR HEADS THE TOWERING & TENEBROUS BOUGHS OF THE CYPRESS MET IN A DUSKY ARCH OF TRAILING MOSS IN MID AIR WAVED LIKE BANNERS THAT HANG ON THE WALLS OF ANCIENT CATHEDRALS... LOVELY THE MOON LIGHT AS IT GLANCED & GLEAMED ON WATER GLEAMED ON THE COLUMNS OF CYPRESS AND CEDAR SUSTAINING THE ARCHES DOWN THROUGH WHOSE BROKEN VAULTS IT FELL AS THRO' CHINKS IN A RUIN DREAMLIKE AND INDISTINCT

QUICKBEAM or ROWAN

WE PAUSED AMID THE PINES THAT STOOD THE GIANTS OF THE WASTE TORTURED BY STORMS TO SHAPES AS RUDE WITH STEMS LIKE SERPENTS INTERLACED A SPIRIT INTERFUSED AROUND A THINKING SILENT LIFE TO MOMENTARY PEACE IT BOUND OUR MORTAL NATURES STRIFE AND STILL IT SEEMED THE CENTRE OF THE MAGIC CIRCLE THERE WAS ONE WHOSE BEING FILLED WITH LOVE THE BREATHLESS ATMOSPHERE

HORNBEAM

WATERCOLOR WASHES

MANY writing surfaces, including those which can be cut into like wood, glass and stone, have inspired the calligrapher. Finding a good-quality surface that will take ink and is not too rough or too smooth is a constant problem. Flecks of fiber in paper and pore marks and different colorings in vellum make good backrounds for calligraphy. In Anglo-Saxon times vellum was frequently stained purple to set off the lettering or gold. But vellum is expensive to buy and requires considerable skill and patience to prepare. However, in an exciting combination of calligraphy and painting, you can create your own backgrounds by using color washes over the coarse surface of watercolor paper.

Good-quality watercolor papers are made by machine, mainly from cotton. They are evenly white and are a little too rough for writing very fine lines. Handmade papers are often tinted and some contain an interesting amount of fiber from flax, which is made into linen, or other papermaking plants. Most handmade papers have a pattern of "laid" lines, which come from the mesh or "deckle" on which they were made. Wove papers do not have these lines.

Most modern papers have size added to the pulp, rather than being sized later as completed sheets, or tub sized, as handmade papers traditionally used to be. To prevent the watercolor wash from affecting the sizing in the paper some modern watercolor papers are tub sized as well. Even so, in order to write over a layer of watercolor pigment, this new surface has to be sized by a dry method using ground sanderac to stop the ink from bleeding into the pigments.

Watercolor pigments

It is useful to understand something of the chemistry of watercolor pigments. Those mentioned in the list below divide into two groups: soluble stains and insoluble, sedimentary colors. By understanding this principle

Papyrus, made from an aquatic plant, was used as a writing surface by the ancient Eyptians, Greeks and Romans (left).

Vellum for calligraphy is usually a calfskin which can be prepared as a writing surface (right).

A selection of handmade papers of varying colours and textures, showing the deckle edge (right).

SOLUBLE AND INSOLUBLE PIGMENTS

SOLUBLE	INSOLUBLE

Alizarin

Burnt Sienna

Phthalocyanine Blue

Burnt Umber

Sap Green

Cobalt

Winsor Yellow

French Ultramarine

Mixture

Raw Umber

Yellow Ochre

Watercolor can be laid with varying amounts of water to create different effects, or in graded and flat washes as on the following pages. The last swatch in each column demonstrates the difference in the mixing ability of the two types of pigment.

Mixture

Illustration by David Kemp

and mixing the different kinds of pigment, you can achieve a variety of effects. A huge range of colors are available to dazzle the unsuspecting student. In fact, all the colors you need can be mixed from a few basic pigments. These are: Alizarin, Burnt Sienna, Burnt Umber, Cobalt, French Ultramarine, Phthalocyanine Blue, Raw Umber, Sap Green, Viridian, Winsor Yellow, Yellow Ochre. Additional useful colors are: Aureolin, Cadmium Red, Cadmium Yellow, Cerulean, Chrome Lemon, Hookers Green, Oxide of Chromium, Scarlet Lake

It is essential when buying watercolors that they should be artist quality. Only with these will you be sure of obtaining true pigment. Student-quality watercolors, or anything which is described as a hue, should be avoided. A hue is often an imitation of an expensive pigment which is quite unlike it in its effect. It will not behave in the same way in terms of solubility or insolubility. The washes described here can be achieved only by using the best-quality artist's watercolors in tubes.

Pigments which are largely soluble include: Alizarin; Phthalocyanine Blue (variously named Winsor, Monestial, Hoggar, Thalo, Phthalo, Helogen); Sap Green; Winsor Yellow (a good primary which is reasonably soluble). These pigments stain the surface of the paper evenly to make staining washes. They mix with each other in water.

Pigments which are largely insoluble include: Burnt Sienna; Burnt Umber, Cobalt; French Ultramarine; Raw Umber, Yellow Ochre. These pigments are sedimentary and used for texture washes. They do not mix with one another. If you mix two sedimentary colors together in a wash, they will precipitate differently. For instance, Yellow Ochre and Cobalt will separate when they are mixed together, with the Cobalt sinking to the bottom of the well and the Yellow Ochre remaining on top. These pigments, when used together in a wash, give an interesting textured surface because the pigments will precipitate before the wash dries, emphasizing the texture of the paper surface.

Basic equipment

In order to use watercolor washes as backgrounds to calligraphy you will need: Artist-quality watercolors in tubes; 2 round watercolor brushes, size 8, containing at least a proportion of sable; 1 palette with 6 deep wells

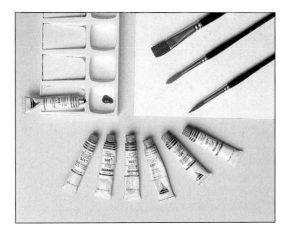

To mix a graded wash, transfer a brushful of pigment from the first well, add 5 brushfuls of water and stir.

Basic watercolor equipment: (clockwise) palette with 6 wells; 13mm (1/2in) flat brush; round brushes, size 8; pad of paper; tubes of artist-quality paints (above).

Repeat until you have 6 wells of pigment.

for mixing washes; a block of watercolor paper such as Bockingford 140lb (300gsm). The advantage of a block of paper is that the sides of the block are firmly glued, which controls the cockling when the wash is applied. Loose sheets of paper are more inclined to curl up, making it very hard to achieve a smooth and regular wash. The advantage of a sable brush is that it holds a wash and allows it to flow on to the paper surface. Nylon brushes do not hold the water properly and they flood.

Preparation

Interesting effects can be achieved by applying the staining colors in a graded wash. Using Phthalocyanine Blue as an example, a wash which starts off very light in color and gradually moves through stronger and stronger tones to a much darker version of the color can be built up.

Put a small amount of Phthalocyanine Blue in the first of the six wells of the palette. Using the round watercolor brush, add five brushfuls of clean water by stroking it on the side of the well. A brushful is when the brush is put into the water and allowed to take up as much water as it will. Mix the pigment and water together thoroughly. This then becomes the darkest element of the wash.

Taking a brushful of the strong pigment from the first well, transfer it to the second. Add five more brushfuls of water to the already diluted pigment. Mix thoroughly and then take a brushful of pigment from the sec-

Start laying the wash at the top of the page using the most dilute well of pigment.

Use a flat watercolor brush and apply pigment in a wavy line, massaging it down over the paper.

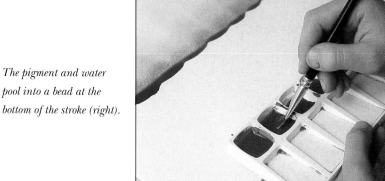

The pigment and water pool into a bead at the bottom of the stroke (right).

Each stroke should pick up the bead of color and draw it down and across the page.

Place a dry, flat brush along the bead. This will absorb the excess color. If the bead is left it will make an unsightly blemish (above).

ond well to the third and add another five brushfuls of water. Repeat this process until you have six wells of pigment, each more dilute than the last. The final well will be a very pale mixture indeed.

Having applied a full brushstroke from the weakest well, transfer a brush of color from the fifth well to the sixth. Add a stroke to the paper before moving on to the fifth well.

Laying a graded wash

The graded wash is laid on to the paper on the block. Working on a drawing board at a fairly flat angle, begin at the top of the paper with the most dilute well of pigment. This wash is applied in a wavy line with the flat watercolor brush. The wavy stroke allows the pigment to be massaged down over the paper surface, moving the pigment around more effectively than if a simple straight stroke were used. The water and pigment pool at the bottom of the stroke in a bead of color. It is very important to maintain this bead of color throughout the wash. If the pigment is allowed to remain on the dry paper without enough water, it will make a sharp line of color rather than allowing for the gradual color change through the wash.

When the wash has been completed, the bead of color must be removed from the paper.

Each stroke that is added to the wash should pick up the bead of color and draw it down and across the page. Having applied two full brushstrokes from the sixth, or weakest, well, take a brushful of paint from the fifth well and place it in the sixth well. This allows for a very gradual mixing of color from one well to the next. A stroke is then made from the sixth well with the pigment from the fifth added to it, before you move on to the fifth well itself.

Each time a stronger color is required, add a brushful of the stronger pigment in the next well. This allows for the most gradual movement of color possible, moving from the very palest color at the top of the page to the darkest at the bottom.

When the wash has been completed the bead of color must be removed from the paper. This can be done by placing a dry, flat brush along the bead. This will absorb the excess color and water from the paper surface. If the bead is allowed to remain on the finished wash, the moisture will move back up the wash through capillary action as it dries. This will leave unsightly blemishes on the wash and ruin it.

The staining pigments give a wonderful variety of color and can be used alone or mixed to give a wide range of graded washes. They color the paper evenly and do not take advantage of the qualities of the paper surface in the same way that the texture pigments do.

Laying a textured wash

Insoluble sedimentary pigments create wonderful textured washes. Because of their chemistry, they will not mix. They precipitate on the paper, leaving one color in the hollows of the pitted surface of the paper while anoth-

Yellow Ochre and Cobalt, with Winsor Yellow, texture wash (left) pale, (right top) darker, (right bottom) more yellow.

Texture wash showing the circular movement of the brush across the paper. The bead of color must be drawn across the dry paper as for graded washes.

Winsor Blue graded wash and an Alizarin Crimson graded wash (left).

er is distributed over the whole surface. This can give a feeling of depth to the wash.

A simple texture wash can be made up by mixing two pigments, such as Yellow Ochre and Cobalt. A large amount of the basic wash can be mixed in one well. The amount of water that should be added is a matter of personal choice and depends on how dark a background you want to achieve. When using these washes in conjunction with lettering, it is important to bear in mind that the background should not be so dark that it detracts from the lettering. Take a round watercolor brush, and apply the wash on to dry paper. Use the brush in a circular motion to agitate the pigment across the paper surface. Each new stroke should pick up the bead of color, adding to it and drawing it across and down the paper.

Texture and stains

The basic texture wash can be made more interesting through the addition of stains. These simply add color to the wash. Take a large amount of Yellow Ochre and Cobalt mixed into a wash and divide it into three wells. Add a small amount of Winsor Yellow to one, Winsor Blue to the second and Alizarin to the third. This will give three very different, colored texture washes from the one basic mixture.

The three colored texture washes can be combined on the page by first laying some of the yellow mix, then some of the red mix and then introducing some of the blue mix. The results are both varied and exciting.

Once you have grasped this basic principle, the possibilities for different colored texture

Stains add color to the wash. Top: Winsor Yellow, Winsor Blue and Alizarin have been added separately to a wash of Yellow Ochre and Cobalt Blue (left) light, (right) dark. Bottom: Burnt Sienna and Ultramarine (left) Burnt Sienna, Ultramarine and Sap Green (right).

washes are infinite. Try some of the following: Alizarin (graded wash); Alizarin (graded wash with Yellow Ochre); Cobalt, Hookers; Burnt Sienna, Ultramarine; Burnt Sienna, Ultramarine and Sap Green; Burnt Umber, Ultramarine; Burnt Umber, Ultramarine and Sap Green; Raw Umber, Cobalt (dark); Raw Umber, Cobalt (light).

Combinations

It is possible to combine two wash techniques. For this you lay a graded wash made with the staining pigments, over which you put a wash of a sedimentary pigment.

Take a pale, graded wash of Alizarin and put this down on the dry paper with a flat brush. When this is thoroughly dry take a pale flat wash of a sedimentary such as Yellow Ochre and apply this with a round watercolor brush over the top of the first wash. The soluble Alizarin pigment allows the white paper to reflect through it, giving the wash a wonderful, luminous glow. The Yellow Ochre wash allows the light to reflect back from itself. The combination of the two gives a glowing transparency to the page.

When using two washes together, it is essential to remember that the staining pigments must be used first. These stain into the surface of the paper and, once dry, they will not move when the second wash is added. However, the sedimentary pigments remain on the paper surface. If a second wash is added to them, they will lift off the surface and mix with the second wash, making an unpleasant muddy color.

The way in which the pigments work together can be best understood in chart form. The soluble staining pigments are put down first and painted in strips down the page. When these washes are dry, the insoluble texture pigments are painted in strips across the page so that they cover the staining pigments.

Writing on a wash

The watercolor washes should be completely dry before any calligraphy is started. Once dry, the surface of the paper should be prepared with finely ground sanderac in a linen bag. Rather than rubbing the paper surface, the bag should be banged down vigorously. This will discharge the sanderac without discoloring the watercolor. When the whole writing

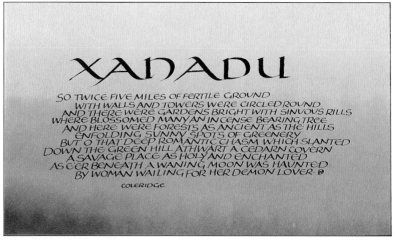

area has been treated in this way, the paper should be dusted well with a feather to remove any surplus sanderac, as this would repel the ink and make the writing less sharp.

Chinese stick ink works well, rubbed down to a fairly thick consistency so that it is very black. The use of colored letters on the colored ground is also possible but less legible. To make them richer and more visible, egg tempera can be used. Mix one egg yolk with two pints (one litre) of water, stir thoroughly and use this to dilute the watercolor paints instead of just water. A pencil can be used to rule up if necessary, but do not press hard into the surface or you will cause unsightly score marks. The pencil needs only to stroke the surface of the paper lightly. It is not possible to erase the lines afterwards since this disturbs the wash and leaves lighter patches on the work. The lines should be accurately measured so that the writing fits exactly on them and no ruling remains visible.

The washes described here can only hint at the exciting possiblities of learning how to paint in watercolor. Experience and experimentation will open up new avenues to explore.

Watercolor wash techniques by Bob Kilvert

Chart showing staining colors in vertical stripes with texture washes of pigments laid over them (below).

Diana Hoare
Xanadu
29 x 25cm (11 x 10in)
Graded wash in Sap Green, Winsor Blue and Alizarin (above).

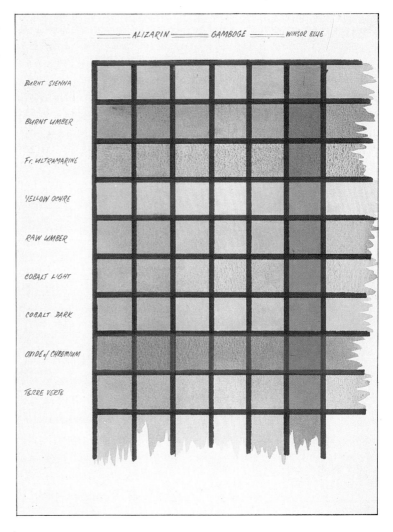

Bob Kilvert
Reeds in the Wind 30 x 18cm
(10 x 7in) Background wash
of mixed Cobalt and Raw
Umber, colored with Alizarin
and Pthalo Blue. Reeds lifted
out with edge of flat brush and
repainted in.

CALLIGRAPHY ON WASHES

THE WHOLE LAND, EVERY DALE & GLEN, WEEPS ITS LONG SORROW AFTER THE GRACEFUL SUMMER; NO TREE-TOP CAN DO MORE, NOR WEEP LEAVES AFTER THAT

NINETEENTH CENTURY WELSH ENGLYN · THOMAS NICHOLSON · ARTIST/SCRIBE : STAN KNIGHT 1985

Stan Knight
AUTUMN

*40 x 26cm (16 x 10in)
One of four panels
representing the seasons.
Based on photographs and
sketches, written and
painted on Arches
Aquarelle paper in
watercolor (left).*

Stan Knight
WINTER

*40 x 26cm (16 x 10in)
The fourth panel of a series
representing the seasons.
Written and painted on
Arches Aquarelle paper in
watercolor (right).*

WHITE FLOUR
EARTH-FLESH,

A COLD FLEECE ON THE MOUNTAIN

SMALL SNOW OF THE CHILL, BLACK DAY,

SNOW LIKE A PLATTER,
BITTER COLD PLUMAGE,

A SOFTNESS SENT
TO ENTRAMMEL ME

VELLUM STRETCHING

THE traditional method of stretching vellum involves damping the vellum, stretching it over a support and letting it dry. Application of glue then ensures that the vellum is held firmly in position over its support, providing a flat, smooth surface. The problem is that vellum stretched in this way often has a rather dead appearance and can produce an unpleasantly hard writing surface. As a result, many calligraphers prefer to complete their work first and stretch the vellum afterwards, despite the possible hazards involved. The method of stretching vellum described below has been developed as an alternative to the traditional way; it is more sympathetic to the vellum, providing a working surface which retains some flexibility and life.

If you begin by stretching a piece of vellum of average size and thickness, you should have little trouble following the instructions. Experience and confidence will soon be acquired with practice.

Equipment

You will need: a canvas stretcher; 8 wedges for knocking into the corners of the stretcher to keep it square; cotton builder's twine or hemp twine for lacing - not nylon or polyester, which is too slippery or stretchy; PVA glue; conservation card; blotting paper; silicone-release

Equipment needed includes (clockwise): vellum, hole punch, wedges, stretcher, builder's twine.

Ruling up the back of the vellum using a pencil and metal ruler.

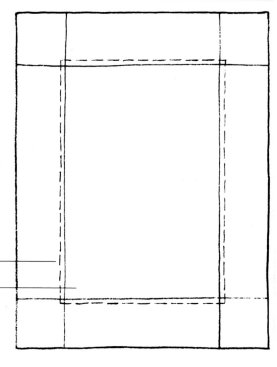

Canvas stretcher with 8 wedges to keep it square (left).

When the vellum is ruled up, the solid inner line marks the size and shape of the stretcher, while the broken line indicates the one allowing for movement of the damp vellum (right).

additional line to allow for movement of damp vellum

position and size of stretcher

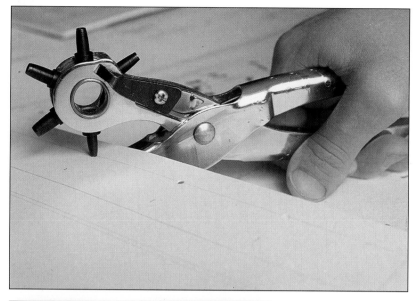

*Use a hole punch for
making holes in the
vellum (above).*

*Glue the top corners of the
card to the stretcher (left).*

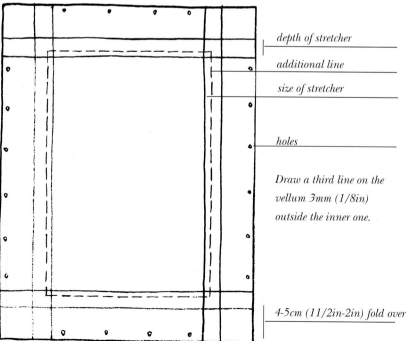

depth of stretcher

additional line

size of stretcher

holes

*Draw a third line on the
vellum 3mm (1/8in)
outside the inner one.*

4-5cm (11/2in-2in) fold over

paper; 2 sheets of polyethylene; a houseplant
sprayer; 2 drawing boards; a weight; a set
square; a hole punch; a metal ruler; and a
scalpel.

Although the system described uses a can-
vas stretcher, a support made of plywood or
marine ply could equally well be used if
desired. In all cases, the wood should be
sealed with polyurethane varnish or diluted
PVA medium. The vellum should measure at
least 5cm (2in) larger than the stretcher.
Check that the latter is absolutely square,
using the set square, and if necessary knock
in the wedges to hold the corners securely in
position. It is an advantage to have a crossbar
on stretchers of 51cm (20in) or more.

Method

Rule up the vellum on the back. The inner
line indicates the size of the stretcher and the
outer line marks its depth. Allow an overlap
of 4–5 cm (11/2–2in) beyond this. Damp vel-
lum has a tendency to move; it can shrink or
stretch. To allow for this movement and to
ensure that the guide lines will still be visible
when positioning the stretcher on the back of
the vellum, a third line should be drawn 3mm
(1/8in) outside the inner one.

Having carefully ruled up the back of the
vellum, mark an even number of holes along

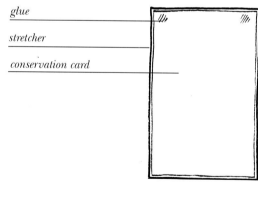

glue

stretcher

conservation card

each side 4–5cm (11/2-2in) apart and about 6-8mm (1/4-1/3in) in, depending upon the size of the vellum. Punch these with the hole punch. To prevent the cord tearing very thin vellum, fold over the outer edge and punch the hole through the double thickness.

Cut a piece of conservation card slightly smaller than the stretcher size. The color of the card will depend on the see-through effect desired. The vellum will look very different over a cream-colored card rather than a stark white one. Colored papers can be used but they may not be acid-free, so you should check this: use as near to a neutral pH as possible.

Lightly sandpaper the edges of the card to obtain a bevel. The card acts as a support, especially when writing after stretching. Using PVA, lightly glue the top corners of the card to the stretcher.

Cut four lengths of cord for the lacing, using the lacing diagrams as a rough guide to calculate the amount of cord required.

Damp the vellum. Make a polyethylene and blotting paper sandwich. First lay some polyethylene on a drawing board and then lay some dry blotting paper on top. Place the vellum face down on this, but insert a sheet of silicone-release paper if it is already written on. Next, damp a piece of blotting paper with a mist sprayer of the kind used to water plants. The damp blotting paper is laid on the back

Dampen a piece of blotting paper with a mist sprayer.

Lay the damp blotting paper on the back of the vellum.

Slide the stretcher with its glued card into position.

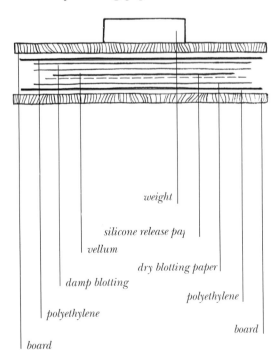

weight

silicone release pap

vellum

dry blotting paper

damp blotting

polyethylene

polyethylene

board

board

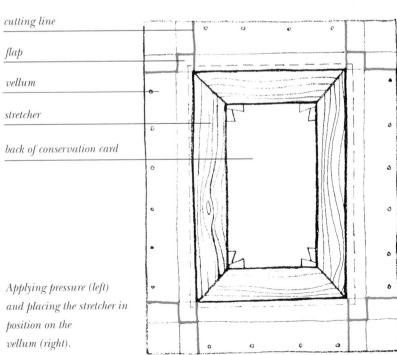

cutting line

flap

vellum

stretcher

back of conservation card

Applying pressure (left) and placing the stretcher in position on the vellum (right).

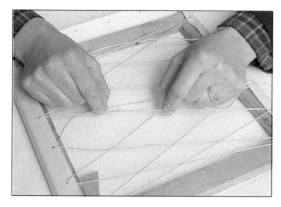

LACING POSSIBILITIES

of the vellum. Two pieces may be necessary for thick vellum or one damp and one dry for thin vellum. Excessive water should be removed before the paper comes in contact with the vellum, by blotting with a dry sheet of blotting paper. A second piece of polyethylene is put on top of this, and finally another drawing board with a weight to supply some pressure.

Leave the vellum for between 10 and 30 minutes, depending on its thickness. When it is damp enough it should feel rubbery. Keep checking after the first 10 minutes. Particular care should be taken with thin skins as they can easily become over-damp. Err on the side of caution; a skin can always be left a little longer.

Remove the weight, board and top layers of paper. It may be best to unroll these carefully since damp vellum has a tendency to curl. The stretcher with the card glued in position may then be slid into place simultaneously. The stretcher should be so placed as to align as closely as possible with the lines ruled on the back of the vellum.

If the lacing has gone wrong, or the vellum has not stretched properly, undo the lacings and start again.

Reef knot with extra twist (top) and postman's knot (bottom).

Alternative lacing (right) Only one set of lacing is shown for clarity.

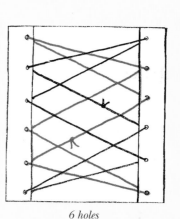

4 holes

6 holes

10 holes (or any even number)

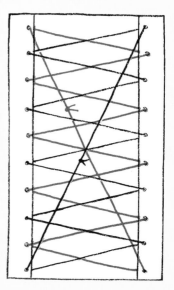

Use the set square against the stretcher, adjust the corners and cut them carefully with a scalpel and metal ruler.

First lacing (right)

flap

waste

flap

Using the set square against the stretcher, adjust the corners if necessary and cut them carefully with a scalpel and metal rule, leaving a little flap to fold around the shorter side.

Lace up the longer sides using two cords. Tension should be lightly firm but not tight. The cords are tied using a locking postman's knot or a reef knot with initial double twist. Tuck in the corner flaps and lace the shorter sides. If a hole tears readjust the tension or punch a new hole. The lacings look complicated but are designed to avoid having a cord running underneath any of the turned-over edges. Note that each cord remains separate, laced and knotted to itself.

Leave to dry. If necessary, adjust the tension in specific areas as the vellum dries; this is particularly useful with larger pieces. If anything has gone drastically wrong or the vellum has not stretched properly, undo all the lacings and start again.

There are certain disadvantages with this method of stretching, but they should not be difficult to overcome. First, deep moldings are required to accommodate the stretcher within a frame. Nowadays this tends to limit the choice of molding, but it is certainly possible to find suitable frames. Second, it can be difficult to keep a stretcher absolutely square. Third, conservation card seems to have a tendency to buckle on larger sizes.

The finished piece showing cords and knots (below).

The first rough for the second attempt at the Ecclesiasticus project was still uninteresting visually.

A new angle of approach produced a second rough which conveyed the feeling of the words far more effectively. This shows two possibilities for the title.

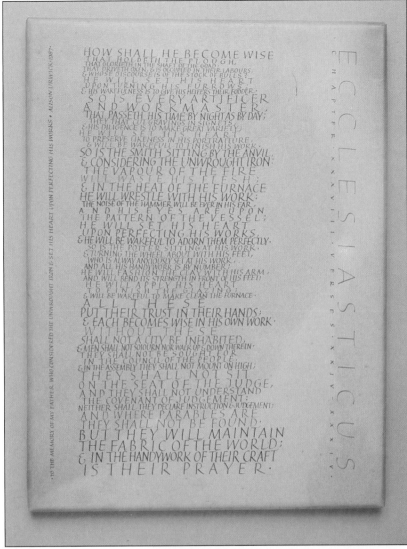

The finished piece is 41 x 30cm (16 x 12in).

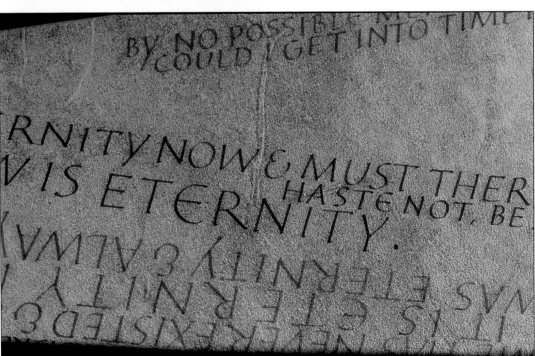

A close-up of the lettering for the "Story of my Heart".

However, these problems are greatly outweighed by the advantages. As the whole procedure is reversible, it is quite difficult to go drastically wrong. The finished piece is lightweight compared to a solid support and if the writing is to be completed after stretching, the vellum still has some life and spring to it, offering a much more pleasant writing surface upon which to work.

Ecclesiasticus project

The wellknown quotation from Ecclesiasticus ch.38 V.25–34 beginning, "How shall he become wise that holdeth the plough..." was read at the funeral of my father, who had been a superb craftsman and engineer. This provided the inspiration for a piece of calligraphy to commemorate the occasion.

My first idea was to use a rather special piece of vellum which had beautiful gray-brown markings. The lettering was to be small square capitals, in pale gray, packed closely together to produce an overall texture. A few important parts were to be in a darker gray and slightly larger. Unfortunately, the rough turned out to be an unsatisfactory shape for the skin and looked too uniform and boring. The close texture would have conflicted with the markings in the vellum and each would

have destroyed the other. As a result, the whole idea was shelved for about 18 months.

At this point, I acquired a piece of vellum with interesting markings in warm brown and cream. The first rough was similar to my previous work, and was still uninteresting. A new angle of approach was needed to convey the feeling of the "fabric of the world", both a living fabric and at the same time a woven one. Eventually, varied letter spacing, warm-brown ink and vertical bands of letters seemed to solve the problem.

The vellum was stretched around a canvas stretcher using the method described above. All the lettering was made with the same steel nib. The brown was a mixture of black and vermilion stick inks, sometimes quite dilute.

In retrospect, the problem with this piece was balancing uniformity and variety. The long text needed to remain a totality and yet have enough variety to maintain interest. It was also one of those pieces which could not be worked to a fixed timescale and instead lay dormant until all the right elements coalesced at the right time.

"Story of my heart"

The idea of trying to cover a three-dimensional shape came from studying limp vellum bookbindings. The shape was made first in stiff paper on a trial and error basis, then in card. This had to be forced into position and was covered in Japanese paper, which is both thin and strong. Starch paste was used throughout.

I found this Richard Jefferies quotation about eternity:

"Realizing that spirit, recognizing my own inner consciousness, the psyche, so clearly, I cannot understand time. It is about me in the sunshine; I am in it, as the butterfly floats in the light-laden air. Nothing has to come; it is now. Now is eternity; now is the immortal life. Here this moment, on earth, now; I exist in it. The years, the centuries, the cycles are absolutely nothing. To the soul there is no past and no future; all is and ever will be, in now. For artificial purposes time is agreed on, but there is really no such thing. Time has never existed, and never will. It is eternity now, it always was eternity, and always will be. By no possible means could I get into time if I tried. I am in eternity now and must there remain. Haste not, be at rest, this Now is eternity."

The words seemed to suit the monolithic

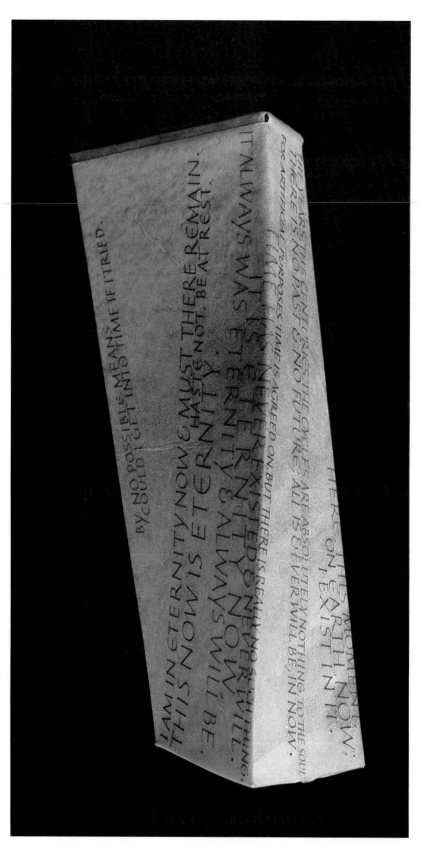

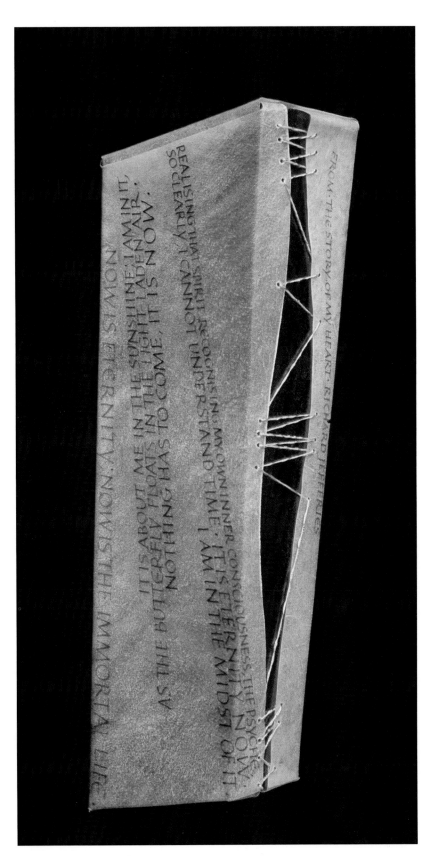

shape I had created, while an off-cut of transparent vellum over black paper produced an appropriately mysterious color. At first, I tried pencil lettering, but it disappeared and became totally illegible, so eventually a gray ink was used. Several paper roughs were made on the shape, experimenting with alternatives and adjustments of line position and letter height. The lacing pattern was also worked out at this stage. The card shape was then covered in black paper. A paper pattern was made for the vellum and the position of the card shape was lightly marked. The writing was executed with a steel pen and dilute stick ink. Small holes were punched for the lacing and the vellum was dampened, cut and folded around the shape. Finally, the edges were laced together using bookbinder's thread and some ancient silver embroidery thread twisted together.

Text and calligraphy by Alison Urwick

The edges were laced together with silver embroidery thread twisted with bookbinder's thread (left).

Three-dimensional shape 20 x 7 x 6cm (81/2 x 3 x 21/2in), covered with transparent vellum over black paper (far left).

IN THE BLEAK MIDWINTER

AS a calligrapher I have an intrinsic interest in words: their content, the sound of their language, the feeling they inspire within me. This interest has given me a passion for collecting poetry and prose from all sources.

Some pieces lie in my collection for years. The initial excitement often wanes until an outside influence gives new impetus. This might be from a variety of origins: a vivid image of nature, a paper of unusual color or texture, a letter shape, or a lettering texture suggested from an unexpected source, such as a magazine advertisement.

The calligrapher walks a tightrope. A balance has to be struck between clearly expressing the meaning of the words and the desire to express an emotional response to those words through the lettering. I enjoy the spontaneity of working immediately, pen to paper, and of the unfolding of an idea. I was drawn to this verse written by Christina Rossetti, hearing it as the well-loved Christmas hymn. The music by Gustav Holst revealed a softness belying the harsh reality of wintry winds.

The language begins sparse and brittle and this made me conscious of the need to reflect its sound in the positioning of the lettering. The hard, precise images of earth and water are subdued by the constant layering of snow on snow. I heard the muffled quietness of past midwinters, and by setting the last line slightly apart, I gave pause for breath. Snow will fall, seasons will pass and winter will come upon us again.

In this piece I chose the light, transparent quality of tissue paper, which possessed within it a sense of wind-torn images. Laying down the paper in a strong diagonal direction created movement, like clouds chasing across the sky. The opening words were set in a white background, representing the blanket whiteness of snow. Cool grays and blues captured the mood of the piece, icy water arrested in the brighter clear blue which "lifted" the design. A creamy white Japanese paper, which had inconsistent thickness of pulp, layered upon the gray tissue paper evoked the drifting snow.

I tore the paper to give a broken edge and by layering the gray and blue tissue paper, I was able to create intensities of color and texture. A spray adhesive proved easiest to handle and it was possible to write upon when completely dry. The letter forms had to be strong enough to avoid competition with the background. By passing a brush of clear water over the word "water" the paint became more intense and the background whiteness of the paper receded, unifying the design.

I used water soluble crayons to give a broken, softening effect which intensified some parts. By not using ruled lines, the composition was able to grow and develop freely.

In seeking to balance the demands of the poem and my interpretation of it, I have, as with all my work, sought to express the unity of hand with mind.

Text and calligraphy by Christine Oxley

IN THE BLEAK MIDWINTER
31.7 x 25.4cm
(12 1/2 x 10in)
Tissue paper layered over white paper. Written in gouache with metal nibs, softened by crayon (right).

Detail showing how texture and color combine with the lettering to capture the mood of the verse.

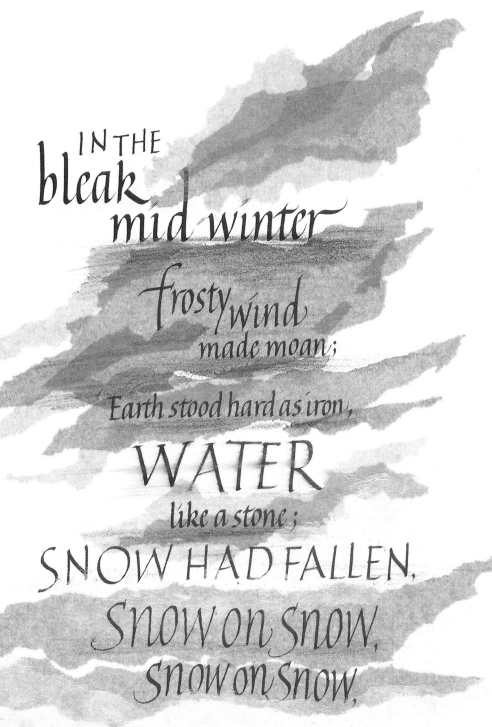

IN THE
bleak
mid winter

frosty wind
made moan;

Earth stood hard as iron,

WATER

like a stone;

SNOW HAD FALLEN,

Snow on snow,

Snow on snow,

In the bleak mid winter. Long ago.

HALLEY'S COMET

NO design is instant. It is hard work developing an idea, but it is always rewarding. The Halley's Comet Christmas Card project required a different approach and attitude from *In the Bleak Midwinter*. The need to produce 40 original cards acted as a restraint upon the design. But, because there were differences, each card possessed a feeling of liveliness as opposed to the flatness of a mechanically-reproduced card.

The trial cards illustrated show the ideas developing one from another until the final design was reached. This method is a relatively quick way of creating original designs.

Text and calligraphy by Christine Oxley

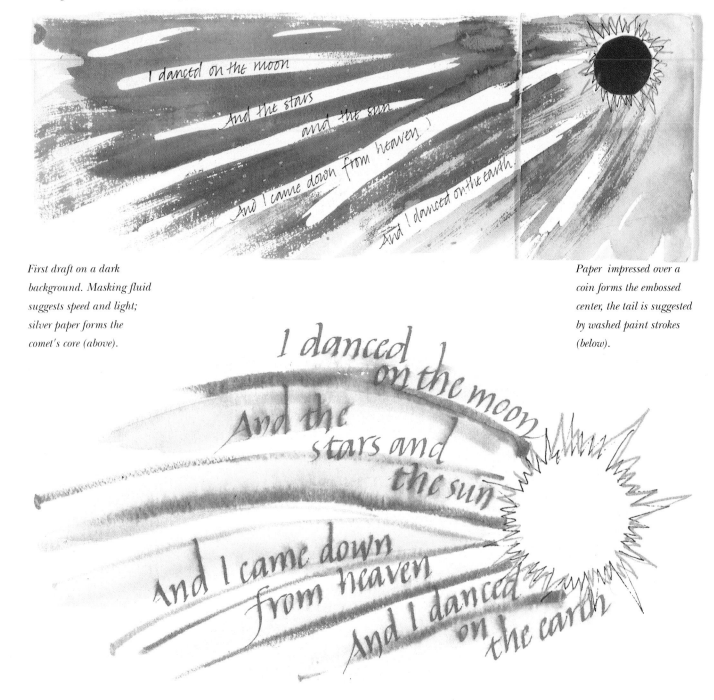

First draft on a dark background. Masking fluid suggests speed and light; silver paper forms the comet's core (above).

Paper impressed over a coin forms the embossed center, the tail is suggested by washed paint strokes (below).

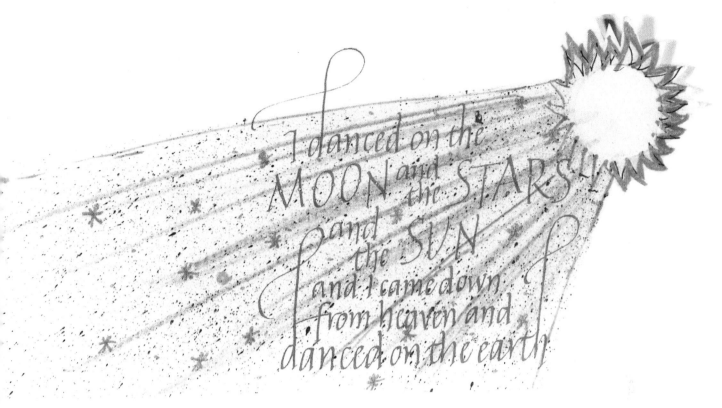

I danced on the MOON and the STARS and the SUN and I came down from heaven and danced on the earth

The tail has been masked and splattered and the text layout changed (above).

The text was too long to write out 40 times; it was replaced and, in the final draft, further reduced (right).

The final design -
13 x 9cm (5 x 31/2in) -
stressed "stars" and
"leap", the comet core was
embossed, and streaks of
pink and blue crayon were
added to the tail (below).

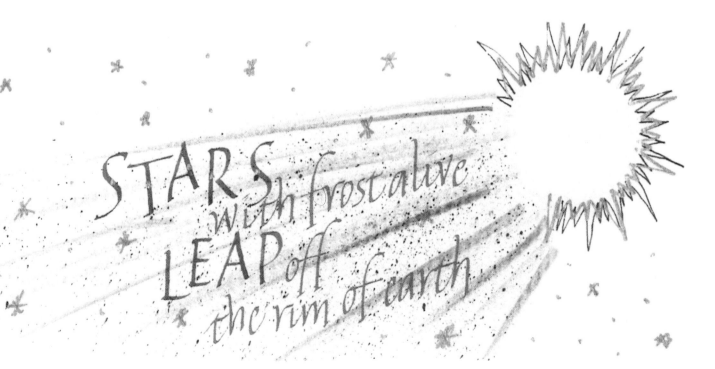

STARS with frost alive LEAP off the rim of earth

WRITING SURFACES

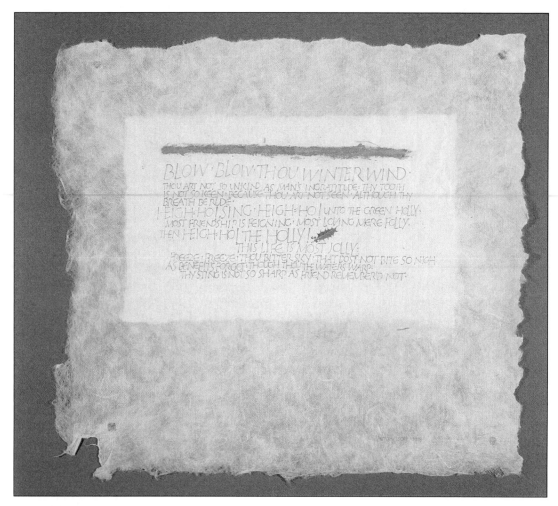

Peter Halliday
BLOW, BLOW, THOU
WINTER WIND

35 x 30cm (14 x 12in)
Pencil, crayon, gold and
aluminum leaf on 18th-
century Nepalese paper.

Liz Farquharson
IN THE WARM HEDGE
GREW

15 x 23cm (6 x 9in)
Embossed letters on
handmade paper.

Liz Farquharson
HEAVEN HAVEN

15 x 23cm (6 x 9in)
Embossed letters on
handmade paper.

Liz Farquharson
SHALL I COMPARE
THEE TO A
SUMMERS DAY?

*15 x 23cm (6 x 9in)
Brush letters written on a
very rough handmade
plant fiber paper. The
letters were built up with a
series of short stroking
movements.*

Sue Hufton
SAILING HOMEWARD

*22.5 x 16.5cm (9 x 6in)
Letters painted in gouache
with a pointed brush on
sheets of handmade paper,
some of which include
plant fragments and dried
grasses.*

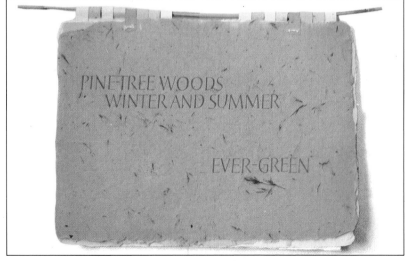

WORDS AS IMAGES

WORDS not only convey information but suggest images. Language itself is born of the double need to communicate ideas in both a direct and a vivid way, coloring meaning with imagery. Calligraphy, the art of writing, can add an important visual dimension.

English is a particularly rich and potent language, drawing its inheritance from a variety of sources. Through the centuries, many linguistic streams have intermingled, giving us a wonderfully precise, varied and expressive vocabulary. Poetry and prose use all these dimensions of language, capturing the sound, meaning and association of words so they resonate in the mind.

Calligraphy, with its ability to enhance words by using different styles, forms and colors, is a perfect vehicle for exploring this vocabulary further in a visual way. For instance, "water" written in a flowing italic hand (top) is perhaps more evocative than water written in stiff, upright capitals (center). And maybe water (bottom) is better still.

Each style of writing has its historical connotations and its personal, interpretive qualities. For instance, gothic is traditionally a medieval book hand, but it could be used now in a personal, idiosyncratic way to suggest other possibilities, such as fantasy or drama. Similarly with color: certain colors have traditional and cultural associations - yellow with warmth, red with fire, green with growth, and so on. But painters can also use color in different contexts and juxtapositions to further their own individual vision. Painters are aware of their historical sources, but each will have a palette that is personally significant. The same is true of the calligrapher, who in some respects is a painter with words.

The traditional way to become a calligrapher is first to study historical manuscript hands. In understanding the shapes of letter forms and the influences that tools and materials have had on determining those shapes, and by the actual process of writing, we as calligraphers gradually evolve our own interpretations of those letters and invent new ones. By acquiring a repertoire of different styles of writing and by understanding the structure of the forms in each style, their significant aspects and inherent potential for development, we expand our ability to communicate ideas effectively. As a calligrapher myself, I feel that I am free to experiment with different styles of writing in order to try and cap-

Calligraphy can enhance words. These three versions of water each evoke a different response. To write it in blue, traditionally the symbolic color of water, goes even further toward capturing the essence of the word - or rather, the perceived essence, as no two people see things in the same way.

Development of letterforms in an attempt to capture the essence of the words.

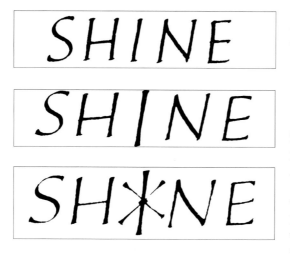

Shine can be developed so that the active flavor of the word is visually enhanced by exaggerating the vertical stress of the "I" (upright lines symbolize the active principle - humans stand vertically on a horizontal plain); the added rays burst forth from a central point, suggesting a shining star of light.

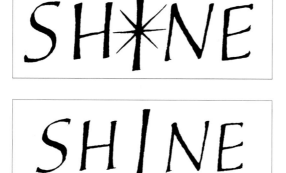

The embellishment of shone reflects the past nature of the event where the emphasis has flowed to the outside circle. If the rays are removed the resonance of the symbolism may still be absorbed subconsiously.

ture what I perceive to be the essence of the words, appraising the potential of possible variations of letter forms within the context and seeing how they can reveal the meaning as illustrated.

Through a process of exploration, assessing the seemingly accidental shapes of letters (remembering that the shapes also indicate sound), I choose only those elements that are helpful to me in that instance. Each context is unique, and what is significant in one situation is not necessarily so in another.

But are the shapes of letters accidental? The English language evolved mainly from Latinate and Germanic roots. From the Latin we derive our intellectual words: for example, consider, circumstance, recognition. Many of these are compound words changing and expanding their meaning with different components. From the Germanic languages come the emotive, monosyllabic sounds: for example, grind, grieve, groan; slip, slide, sling and slink. Some of these words have obvious onomatopoeic origins.

However, there are also many etymological theories. One of these concerns vowel sound groupings. The more active and present the verb, the sharper and thinner the vowel sound: for example, sink, sank, sunk; drink, drank, drunk. Thus, shine and shone could be developed as illustrated.

In working with letters, I find I am increasingly aware of these apparent coincidences and feel that my task is really to uncover, if I can, what is already potentially there. And calligraphy, with its range and subtlety, is for me the perfect instrument.

Obviously, careful thought and discrimination are needed in developing letters and words in this way, as interpretation can obscure the text as well as reveal it. However, as with playing a musical instrument or reading a play, any rendering necessitates personal intervention, and in the end perhaps all we can do is believe in what we do and be as truthful as we can to our own vision of the words, though this may change as we explore.

More important, in the actual process of exploration and experimenting with the letters and words in order to portray them on the page, we discover more about the words themselves. We bring our own insights, experiences and discoveries to the making of them, and in this way find out more about how and what we think. Thus, exploring words can also be a way of exploring ourselves.

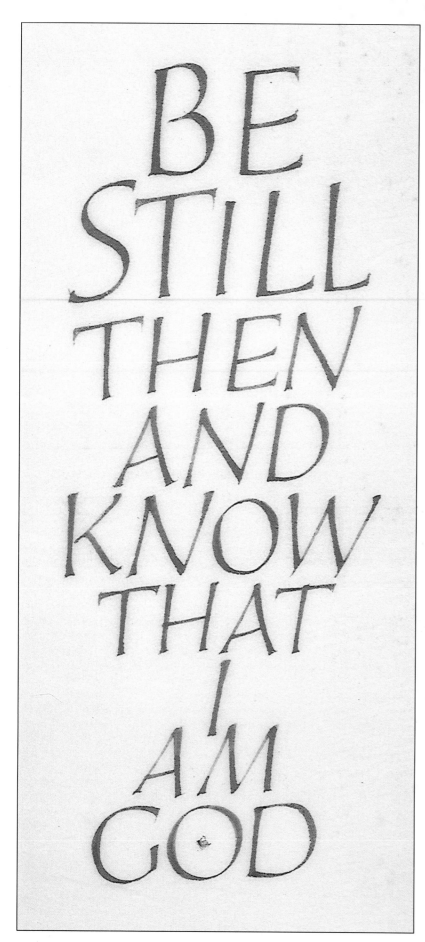

Be still and know that I am God

As experimenting with the shapes and arrangement of letters can present a way of discovery into the deeper meaning of words, the same is true with whole phrases. This verse from Psalm 46 seems to be exceptionally profound, and gives rise to many possibilities, thoughts, questions, associations and meanings. All the pieces are in watercolor with raised and burnished gold, on vellum. In this series the captions are self explanatory.

Text and calligraphy by Ann Hechle

From Psalm 46, verse 10 *12 x 6.5cm*
13 x 6.5cm (5 x 21/2in) *(41/2 x 21/2in)*
The emphasis is on stillness (bottom)

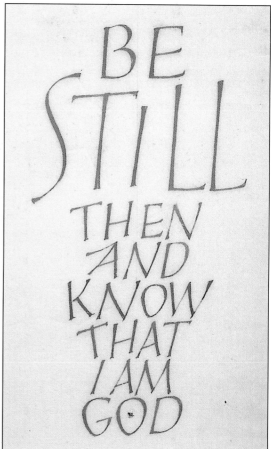

DISCOVERY INSTITUTE PRESENTS:

Truman Capote's

A Christmas Memory

This holiday season's classic one-act play

Saturdays & Sundays

Nov 22 and 23
Nov 29 and 30
Dec 6 and 7

8:00 PM

$10

Reservations are recommended
For reservations and directions: 845-255-4126

THE SCHOOLHOUSE AT DISCOVERY INSTITUTE
64 PLAINS ROAD, NEW PALTZ, NY 12561

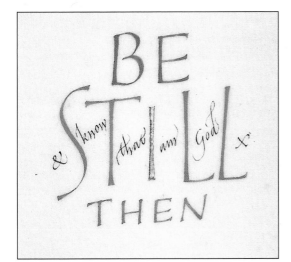

6.5 x 6.5cm
(21/2 x 21/2in)
The center of the stillness is
the same as the "I" of God
(top).

12.5 x 6.5cm
(41/2 x 21/2in)
The center of the stillness is
echoed by the "I" of "I am
God" shown by the gold
"I" (right).

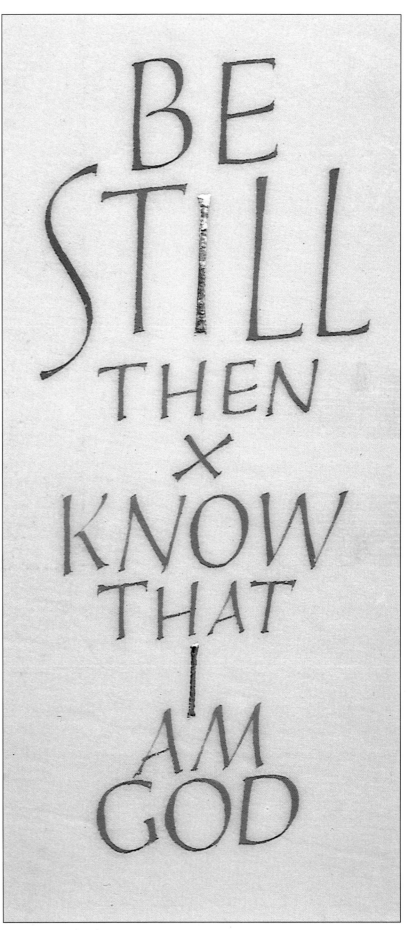

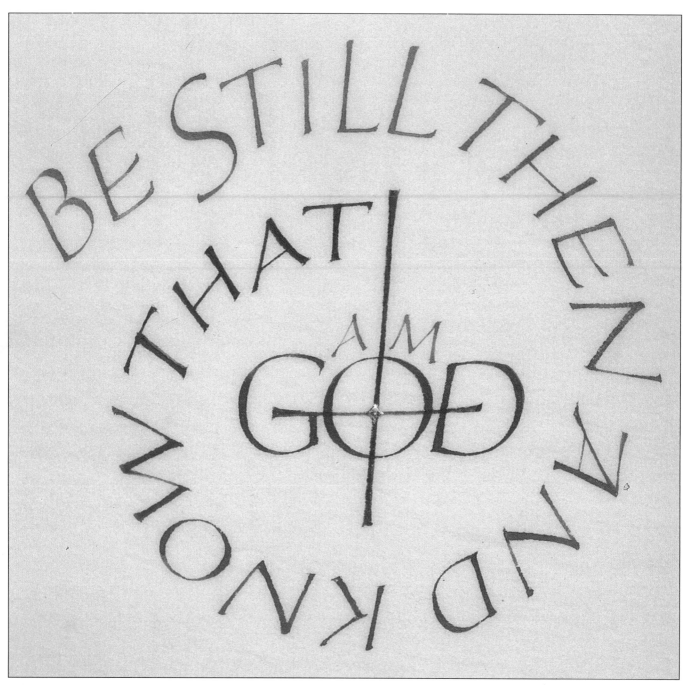

6.5 x 10cm (21/2 x 4in)
*Two equally balanced and
related phrases. The
linking ampersand is
emphasized in gold (left).*

9.5 x 9.5cm
(31/2 x 31/2in)
*Through stillness, there is
a spiralling inward to
where the vertical,
temporal, moment by
moment "I" meets and
fuses with the horizontal*

*and eternal God. Where
these two lines meet forms
the critical moment of
"now" symbolized by a
gold point (above).*

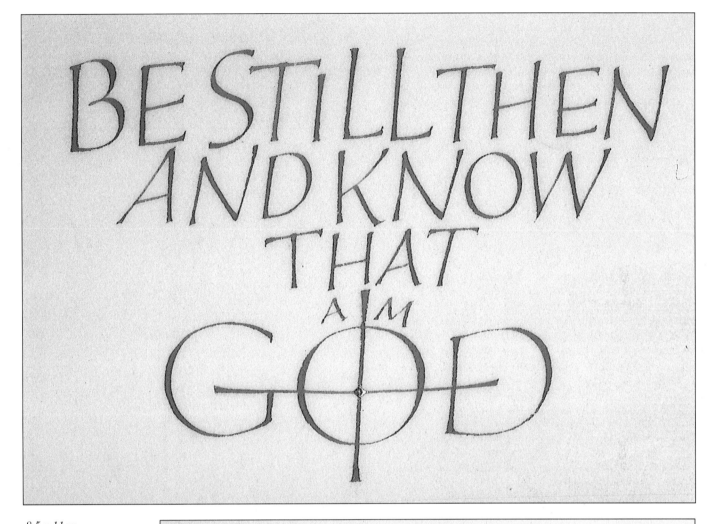

8.5 x 11cm
(31/2 x 41/4in)
The moment of "now" takes place in the center of God. By using capitals, the letters form an image which is very nearly symmetrical - an idea that is reflected throughout the series (top).

6.5 x 11cm
(21/2 x 41/4in)
"Knowing" or intuitive understanding lies between the practice and the outcome. Is this true of other things we do? (right)

FLOURISH DESIGN

FLOURISHES offer endless opportunities for creative design, with possibilities ranging from elegant, restrained decoration of formal scripts to freely made, exuberant and more complex examples. They may enhance lettering in a wide range of contexts from compositions with prose or poetry to graphic design work, sign writing and inscriptions.

During the Renaisance flourishes developed as natural enhancements to italic scripts and reached remarkable heights of inventiveness in the works of such masters as Arrighi, Palatino, Tagliente and Mercator. In addition to using flourishes to decorate italic scripts and their related capitals, some of these masters, and subsequent scribes, used them creatively with gothic scripts, and the evolution continued in later centuries, with the adaption and development of flourishes for copperplate writing. The Renaissance and the later periods of copperplate development are rich sources of reference material for flourish design, while much contemporary calligraphy shows the versatility of flourishes in modern contexts.

Flourishes should be appropriate to the situation. Some instances will call for restraint and refinement while others will require licence and invention, but at all times good letter form should be a prime consideration and the text itself must be the key to determining suitable flourishes.

Undoubtedly, some people are able to design and write successful flourishes intuitively, but the following guidelines can be used when a more methodical approach is required.

Flourishes should be natural extensions of the letter and not appear as disjointed additions.

Work from the simple to the complex. An understanding of some basic principles of flourish design and straightforward flourishes gives a springboard for experiment.

Flourishes should be flowing and the whole arm must move freely. Initially they may have to be written slowly, until the design and hand movements are familiar enough to allow spontaneity.

In learning basic flourish designs, it may help to write component strokes separately. Pen lifts may help, but you should practice executing a flourish in one continuous movement as soon as you are able (except where the nib is too large to allow this).

ABCDEEFFGHIIJK
LLMNNOPQQRSTU
VVWWXYY&Z

Swash capitals written with a Rexel 11/2 roundhand nib.

Flourished capital "o", written with a Rexel 4 roundhand nib.

Flourished capital "y".

Flourished capital "z".

Flourished "g" combining
thick and thin nibs.

Flourish with a double
stroke nib.

Flourish with a thin nib.

Flourished italic
minuscule "g", written
with Rexel 4 roundhand
nib.

Flourish designs can be planned in pencil, then traced over through layout paper with a pen or copied until they can be written accurately but freely. It is not necessary to keep rigidly to the design, as liveliness should not be sacrificed. However, good design must be retained. Good design, pen control and spontaneity are the essential components of successful flourishing.

Initially it may be preferable to practice flourishes with a small nib, such as a Rexel

Flourished italic
minuscule "j".

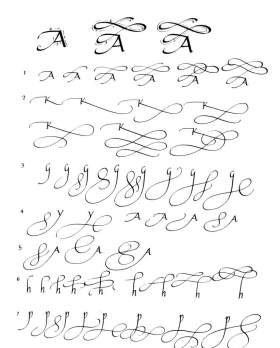

Flourished italic
minuscule "p".

The three "a"s in the top
row show the stroke order;
the third is more
spontaneous than the
second. The following

seven rows show the main
flourish directions; each
row contains a selection of
simple and complex
flourishes (right).

no. 4, as it is easier to push against the front of a thin nib, especially when making swift, continuous movements. The same flourish designs can subsequently be written using progressively larger nibs, rather than moving suddenly from narrow to wide nibs.

Generally, keep flourishes well away from the body of the letter; they should not look cramped.

Flourishes should be added to their specific letters as soon as possible, so that they look like an organic part of a well-formed letter.

Flourishes usually take up a fairly generous space, often elliptical in shape, but sometimes more circular

After learning a selection of basic flourishes, try some spontaneous flourish movements, without any pre-planning, as extensions from specified letters. These quick ideas will be facilitated by the use of a pencil, which is easier for rapid movement than an edged tool, or a pointed fiber tip, but a thin-edged nib or narrow quill nib are also suitable. (A well-cut quill offers less resistance on push strokes than a metal nib, especially on surfaces such as vellum or textured paper, although with practice a metal nib proves adequate in most instances.)

Diagonal strokes should be parallel in most cases, especially in more restrained flourishes, and not too close together. At cross-over points thick strokes should cross thins.

After practicing on layout paper, practice on the paper (or vellum) that will be used for

Publicity sheet for a one-day calligraphy workshop (bottom).

Flourished "k"(right).

"Kalligraphia" sampler including italic variations (left).

Ampersands: a selection of the many possible flourished variations.

the finished work, as a different surface may affect the movement of the pen and the ink flow.

For lighter-weight flourishes on heavy-weight lettering use either the corner of the nib or a thinner nib. A combination of heavy and light-weight flourishes can be used.

Large-scale flourishes written with a wide-edged felt marker on a roll of lining paper afford good practice in loosening up since sweeping arm movements have to be made at this scale.

Text and calligraphy by Gaynor Goffe

He that plants trees loves others besides himself

PROVERB

An unplanned flourish using the edge and corner of an automatic pen (below).

Flourished italic quotation written with Rexel 2 roundhand nib (right).

Selection of flourishes written by Christopher Haanes, Norway. (far right).

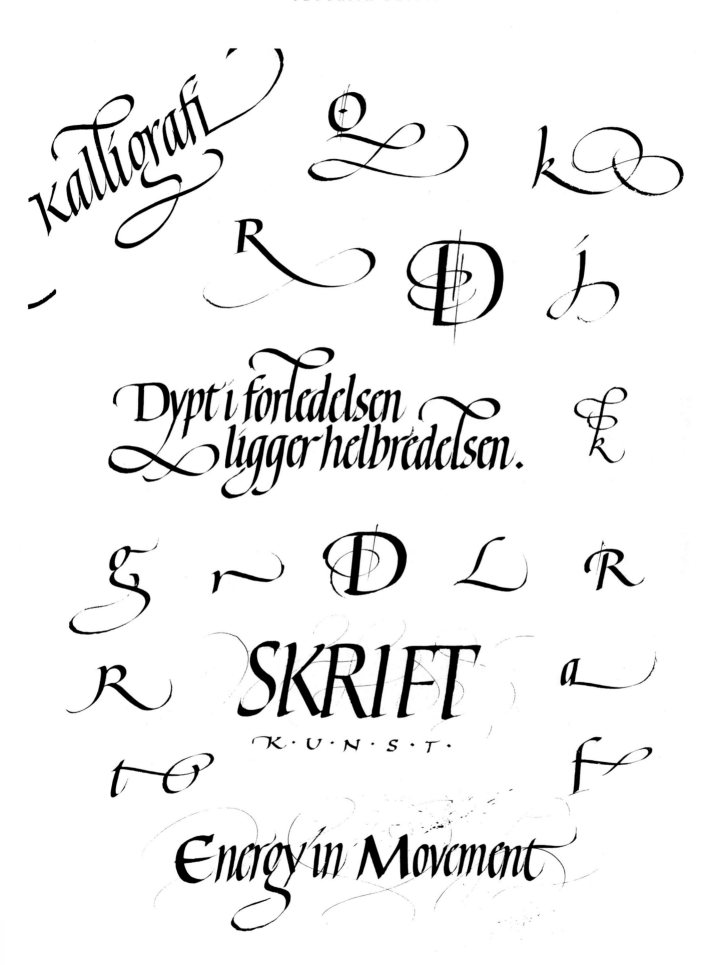

FLOURISHES

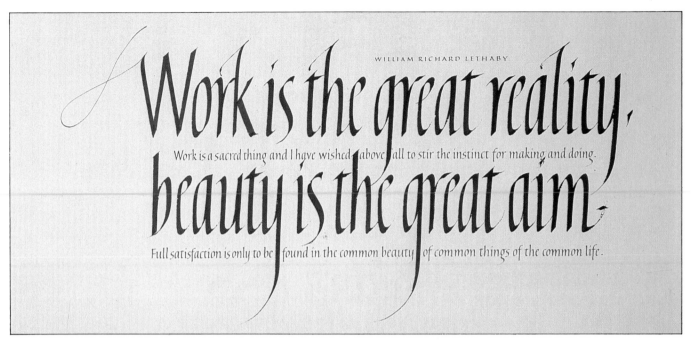

WILLIAM RICHARD LETHABY

Work is the great reality,

Work is a sacred thing and I have wished, above all to stir the instinct for making and doing.

beauty is the great aim.

Full satisfaction is only to be found in the common beauty of common things of the common life.

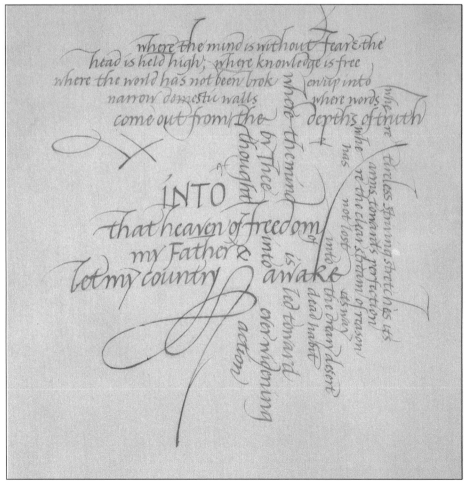

David H Nicholls
WORK IS THE GREAT
REALITY

40 x 79cm (16 x 31in)
Written in Chinese stick
ink and gouache, with
automatic pen and quills
on Khadi handmade
paper.

Simon Blake
GITANJALI
(SONG OFFERINGS)
NO 35

23 x 25cm (9 x 93/4in)
Watercolor on stretched
vellum, using a goose
quill.

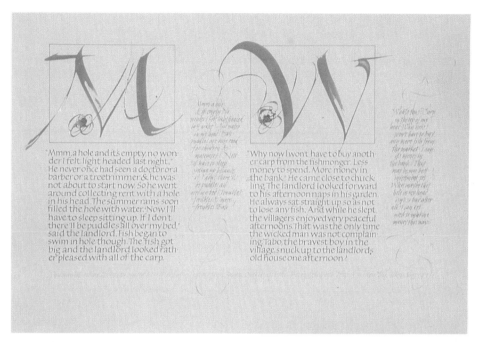

Georgia Deaver
ONCE UNDER THE
CHERRY BLOSSOM
TREE

25 x 33cm (10 x 13in)
A page from a book. Stick
ink, gouache and gold.

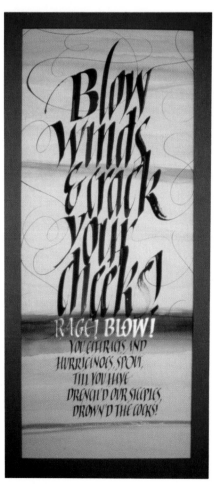

Denis Brown
BLOW WINDS

34 x 81cm (13 x32in)
Gouache and gold leaf on
gesso and powdered gold
laid on Saunders paper, to
which a colored wash has
been applied.

CALLIGRAPHY AND POETRY

CALLIGRAPHERS usually write out texts which were originally written by someone else, and consequently they have an obligation towards the author not to destroy the intended meaning. Edward Johnston used to impress on his students the importance of discovering and carrying out the author's intention. One of the questions he would ask his class was whether they would be prepared to meet St John if they had written out "In the beginning was the Word" and started with an ornament or interruption which might distract the reader from the words. But, is it possible to know what St John, or any other author, would feel about their words being written out by a calligrapher?

The ideas and opinions of writers are as varied as those of any other group of people; a poet once told me she could concentrate properly on a poem only if it were typed or typeset. Any calligraphic version of one of her poems, however simply written, was seen as the scribe intruding their own interpretation on her words. Other poets are delighted when their work inspires a calligrapher to the extent of writing it out. Essentially, the success or otherwise of a calligraphic version of any text depends to a great degree on the amount of sympathy between the author's and scribe's visions.

Understanding the words

However much a calligrapher intends to convey the author's exact meaning of the words, it is not always clear what those words mean. We do not necessarily know what the author has written - only rarely does the text submitted to a publisher reappear in print in exactly the same form; major or minor alterations will have been made, and the author will often have agreed to a compromise in place of the original preferred wording. As calligraphers, we usually have only the published text to study, and must work from that, but we still may not understand what those words mean. This is particularly so in the case of poetry, which is such a condensed form of communication that it often points towards rather than explains an experience, emotion or meaning, and can often only be truly understood by someone who has had a sufficiently similar experience to that of the poet.

An additional problem in attempting to understand the meaning of a poem is that we

As morning awakes
in the still grey sky
And a scamper of snowflakes
rise up on the wind
Spring warmth reaches out
and touches the earth
As snowdrop by snowdrop
the winter ends

FEBRUARY
20.5 x 22cm (8 x 81/2in)
Gouache on paper. This simple format is based on the typed text, the only alteration being the indented alternate lines. This was to resolve the visual problems caused by the line lengths.

THE FLAME AND THE ROSE
33 x 46.3cm (13 x 18in)
Watercolor on paper. This extract has been written in a static form of italic. The large area of white space accentuates the sense of stillness.

from her shining bower
on the first evening star
Venus cast down
one lonely white bloom

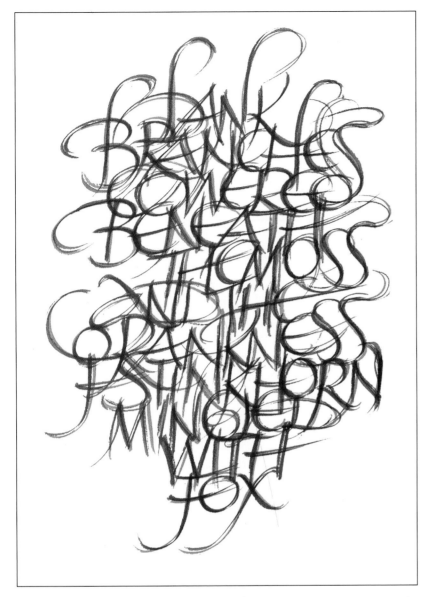

DANK BRANCHES
COWERED BENEATH
THE MOSS AND THE
RANKNESS OF
STINKHORN
MINGLED WITH FOX
38.5 x 52cm
(15 x 201/2in)
Felt-tipped pens on paper.
Extract from a poem. The
tangle of writing was
suggested by the
intermingling of branches
in a wood.

range of possible interpretations of entire sentences becomes apparent.

Presenting the words

Given these problems of really understanding another person's words, it is an extremely difficult task for the calligrapher to carry out the author's intention. It seems important, therefore that we at least try to understand the text as far as we are able, and from then on endeavor to follow one of Edward Johnston's other guiding principles: letting what we are writing guide the work. If we write out a poem in the most straightforward way, allowing the printed version to direct the design, we are least likely to inadvertently destroy or alter the original meaning. But even then, choices still have to be made about style and size of writing, color, word spacing, line spacing, and the weight and texture of letter forms, so that the reader is distracted as little as possible from the reading of the words. Our choices should be considered ones, suggested by the text: to write out William Wordsworth's "I wandered lonely as a cloud", a fresh pastoral poem, in a heavy red gothic hand would be quite inappropriate. Similarly, on the few occasions when a poet's feelings about the appearance of their work are commonly known, it would be an unacceptable intrusion if the scribe disregarded those wishes, as would be the case if e.e. cumming's poetry were written out in capitals when he specifically chose to write it in minuscule.

Allowing the words to direct the work does give the calligrapher a remarkably wide range of possibilities. On the one hand, there is the method of minimum intervention - choosing the most appropriate color and style of writing and then keeping as faithfully as possible to the printed version when executing the calligraphy. At the other extreme is "word-painting", which may be an illegible pattern of color or texture, its aim being to capture the mood of the words rather than to reproduce them clearly. Between these two ends of the modern calligraphic spectrum lie seemingly unlimited possibilities: emphasis of individual words or stanzas by changes of color, size or style, taking extracts and incorporating them into a collage, rearranging the designs, altering the shape or division of the verse, etc.

Not all the options are equally valid, however. For example, if we write out the first line

cannot necessarily assume that the poet fully understands it either. In their own different ways, many poets have said that poems are sometimes only understood by them after they have been written, that poets write in order to understand rather than to explain, that poetry can communicate without being understood. It can be as much a process of discovery for both poet and reader as a means of communication from poet to reader.

A further difficulty is that however precisely we use a language - and usually we do not - it is not always interpreted in the way it was meant. The same words, although meaning broadly the same thing to all of us, have different associations depending on our own backgrounds, character, education and interests. For example, to some a blackbird is a friendly garden bird with an attractive song, while to others it is a black bird and as such is symbolic of evil. If a common word such as blackbird can give rise to two quite different ideas, the

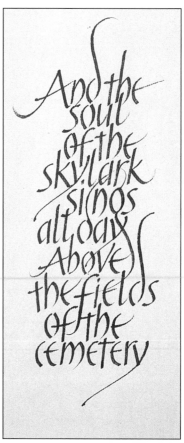

AND THE SOUL OF
THE SKYLARK SINGS
ALL DAY/ ABOVE THE
FIELDS OF THE
CEMETERY
16.5 x 36cm (6 x 14in)
Felt-tipped pen on paper.
Extract from an
unfinished poem.

of William Blake's poem "Night" - "The sun descending in the west" - with the word "sun" in orange and "descending" visually descending below the rest of the line, we are undoubtedly being guided by the words themselves. But the poem in its entirety would have been ignored; the descending sun is not of outstanding importance in the poem, but in the calligraphic version it will stand out and distract the reader from what follows - unless, of course, the whole poem is written out in a similar manner, with the "stars" shining in silver or gold, "birds" written in feathery italic and "heaven's high bower" appearing above the rest of the text. When this sort of interpretation of a poem is carried out, it is invariably the hallmark of an amateur having great fun. But it is not a sign of the well-considered piece of work which results when the scribe has taken into account not just the individual words but the mood or idea they convey when combined, as well as the visual result.

Everyone has to decide for themselves what they feel is an acceptable and valid interpretation of the words they are transcribing. I write poetry, and find that since I have been writing out my poems calligraphically, my self-imposed rules on interpretation of text have become much more strict. Previously, although my starting point had always been the meaning of the text (as I understood it), I became so involved in the design possibilities which presented themselves that ultimately I would allow the visual side to completely take over. The words themselves, like the pens, ink and paper, became the means to the end, which was the visual design. Often I would emphasize certain words or lines, but I am now so disturbed by the destruction of the overall pattern and rhythm of the poem when selected pieces are highlighted that I can no longer work in this way. To have an equal interest in conveying the sense of the words and displaying them in a visually satisfactory way presents a constant conflict of interest.

Three approaches

I have, however, found three different ways of writing out poetry which satisfy both the calligrapher and the poet in myself. The first is to present the words in the most neutral and legible way, the scribe emulating the role of the printer in simply making the text available to the reader. Punctuation cannot be adjusted or omitted, nor capitals altered to minuscule; if a verse is aligned on the left it cannot be centered. Straightforward though this may sound, this simplicity can set up quite considerable design problems for the calligrapher if the lines of the verse are of unequal length or are irregularly indented. The unbalanced appearance in these cases has to be resolved by what are often very subtle adjustments of size and weight of title, author and any additional information to the main piece of text, in an attempt to give an overall appearance of balance. Care needs to be taken with even seemingly small changes, such as breaking a particularly long line into two shorter ones; it should be remembered that if the poet had wanted two shorter lines, that is what they would have written. Any deviation from the original layout might affect the meaning. This also applies to titles - sometimes the title is just a title and at other times it can be an essential part of the poem, giving a further, and perhaps vital, meaning to the words which follow.

Sometimes a design really cannot be resolved satisfactorily without some deviation from the printed layout, and then, if the calligrapher is to carry on, a compromise has to be reached to give sufficient freedom for the problem to be resolved in the new medium. Calligraphers cannot produce their best work if they are being hampered by totally rigid

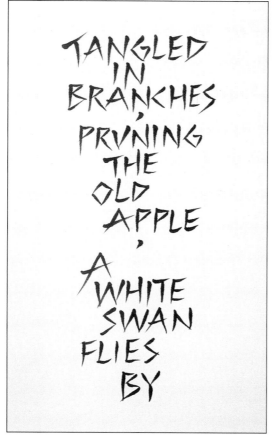

TANGLED IN BRANCHES

*17.7 x 31.6cm (7 x 12in)
Japanese felt-tipped pen on
paper. When a calligrapher
writes poetry, sometimes a
calligraphic rather than a
printed rendering of the
words is immediately
envisaged. Additional
space between the second
and third lines indicates a
short pause in reading.*

restrictions on design, any more than poets can write their most impassioned verse if they are inhibited by being told to produce lines of equal length, with alternate lines indented and without using "k" or double "o". In any creative work there needs to be a marriage between control and freedom, technique and imagination.

The second method I find acceptable resolves the difficulties which arise when I would like to emphasize certain lines but do not want them to intrude on the rest of the poem. I then remove the selected words from their context and let them stand alone so that their visual appearance no longer affects, or is affected by, the rest of the poem. I then feel free to treat them in any way that seems appropriate as, when isolated, they cannot alter the statement the poem as a whole is trying to make.

The third solution is again to write out the poem in its entirety, but instead of transcribing it in a simple format, the poem is transformed into something more akin to a painting in which I am trying to recapture, or recognize, the emotions or moods - fear, sadness, ecstasy, movement, stillness - of the words and to present that emotion or mood again, but in a different form. The aim is no longer to write out the words as legibly as possible but to use the words as a starting point for a piece of work in another medium. The result is to be looked at rather than read. I feel very strongly, however, that any poem (or extract from a poem) written out in a complex or illegible visual way should be presented next to a neutral printed version, so that the poem can also be read in its original format.

Abstract images

Why bother to write out the words at all if they can not be read? Why not simply produce an abstract painting which mirrors the feelings of the poem? This has, of course, already been done successfully; and conversely, poems and music have been based on paintings. For a painter to convert a text into a painting would be an obvious course for a painter, as every specialist thinks in terms of their own trade. A calligrapher, however, thinks and functions in terms of visual words, and consequently their paintings are likely to contain letter forms rather than abstract shapes and colors. Is this still calligraphy? Why not? The same basic understanding of the craft, the letter forms, the relationships of those forms to each other, changes of weight and texture, use and mixing colour, knowledge of tools and materials, is as necessary in an abstract piece of work as in a straightforward one.

However we choose to write out poetry, a certain amount of conflict between the poet's aims and those of the calligrapher seems inevitable, as to transfer anything from one medium to another requires some unavoidable changes. To minimize this conflict, it is important that the calligrapher should work with integrity, giving texts as much thought, consideration and skill as possible. It is all too easy for the scribe to be self-indulgent at the expense of the author. We should try to understand which rules (both calligraphic and literary) we are breaking, and why, and we must feel we could fully justify what we have done if we ever had to face the author. There will be few calligraphers of the stature of Shakespeare, Goethe, T.S. Eliot or David Gascoyne, and we may never be able to do justice to their work, but it is vital that we give as much of ourselves to the work of transcribing another's words as the author gave when writing them. It is the spirit in which the work is carried out which is important and which makes the difference.

Text, calligraphy and poetry by Heather Collins

Fire

Flames flick their tongues
 and hurl themselves with menace
 into lurking corners

With brooding, glowering beauty
 they crackle in furious rage
 as they overpower
 in a blaze of passion

And a surge of union by sacrifice
 scorches a hole in the dark

Fire the purifier
 bursts to a white light heat
 that unifies, illuminates,
 and is gone

In the ashes,
 waiting for the three moons,
 the phoenix, in dignity,
 is ready for the dawn

© Heather Collins

FIRE

18 x 36.5cm (7 x 14in)

Watercolor on paper. The

poem can only be

deciphered with difficulty,

which means a printed

version should accompany it.

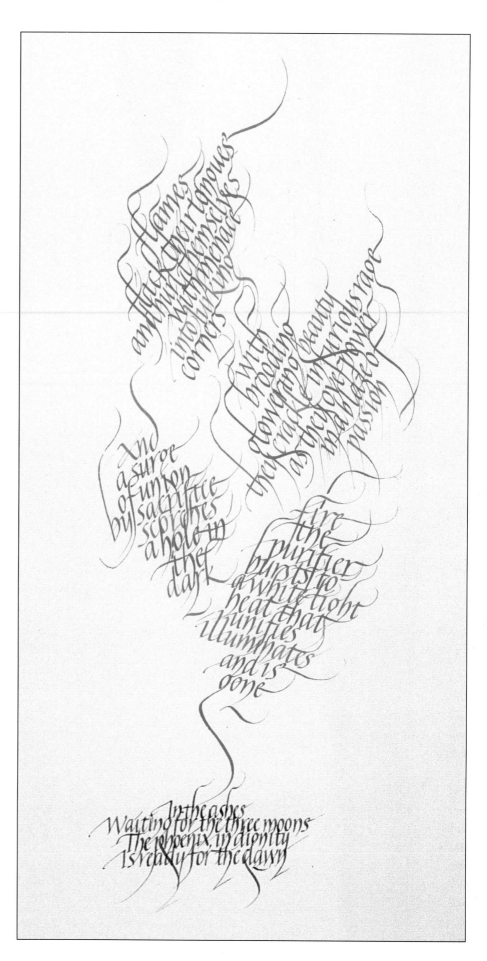

Water

Alone in her refuge
the Great Goddess slumbers
awaiting her full term
In unhurried rhythm
of flux and change
her waters circle

Submerged in the soundless grip
of tendrils
the sacred wells lie still
Withered oaks rattle
their bare-boned twigs
in impotent languor
Springs run silent,
apprehensive of the birth

Her hour is come!
The waters unite
bursting in torrents
splashing and saturating
in glorious fulfilment
of their union
In floods of exuberant force
they spiral down
on an unsuspecting earth

Later
In an arid desert
a gentian rises
Cool and pure

© Heather Collins

WATER

26.5 x 31.4cm

(101/2 x 12 in)

Watercolor on paper. The entire poem is reproduced, mostly as background texture. The words which convey movement are highlighted and their order varies from the original. Whereas the poem is partly about life-giving rain falling after drought, the calligraphic version only concentrates on the earth's revival.

ELEGANT THINGS

MY book *Elegant Things* started as a somewhat unpromising set piece for an exhibition. From a choice of several texts only the "list" from the 17th century *Pillow Book of Sei Shonagon* seemed to be a possibility. All the items on the list evoked strong visual images, and although some of them had sentimental overtones, others suggested more formal and abstract patterns.

I began to work with watercolor on pieces of soft handmade paper, but the results looked either too folksy or too expressionistic. I then drew various elaborate patterns on smoother paper to illustrate "rock crystals" or "plum blossom", but these were either too graphic or too elaborate. Finally the word "elegant" proved to be the key. To me it conjured up ideas of simplicity and stylishness - a certain sparse refinement. I began to think that in order to "let the words speak" I must pare everything down to a minimum, with little or no decoration. I wanted to write out the "list" in such a way that the finished piece had a personal mark, but also allowed those looking at it to conjure up their own visions of "shaved ice...in a new silver bowl" or "plum blossom covered with snow".

The lettering was done with a metal nib, using white gouache on black paper and black gouache on white paper.

Design

I rejected all my original ideas about color and pattern and decided the piece had to be in black and white. At this point I started trying out various types of writing. In a rather pedestrian way, I at first thought that a list should be a list - with one item below another - but line lengths varying from two to 13 words caused obvious problems. However, I liked the style of lettering shown in the illustrations and, as the letters were rather wide in form, the long lines became even longer. In order to use this quality positively, I decided to write each item on a long, narrow, separate sheet.

I now had the bones of the structure. It would consist of separate sheets making a book; its shape would be wide and thin; its color would be black and white, and I knew the form the lettering would take.

Two questions now needed answering. First, would the conventional black ink on white paper be interesting enough, and if not, how could it be varied? Perhaps some sort of simple counter change - black on white, white on black - would provide enough variety. Second, should black or white predominate,

The pages were fixed together with dowel painted the same pink as the page edges. Note the thin black and white lines alternately separating the pink edges.

and why? Eventually, I decided on black because, in many contexts, it has become synonymous with elegance.

I tried writing out the pages with black gouache on white paper and with white gouache on black paper. As to the size, I cut up pieces with dimensions and scales which seemed appropriate for the writing.

Having written the roughs, other problems arose. Paper proved to be too insubstantial; the whole structure was floppy. Also, the text looked wrong centered on each sheet and the overall effect was rather dull.

More decisions had to be made at this stage. They were, first, to use paperboard instead of paper; second, to range the text

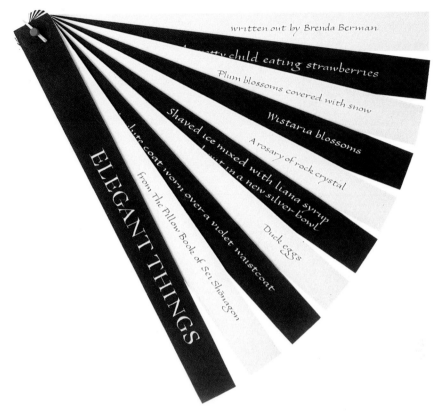

written out by Brenda Berman

pretty child eating strawberries

Plum blossoms covered with snow

Wistaria blossoms

A rosary of rock crystal

Shaved ice mixed with liana syrup
I put in a new silver bowl

Duck eggs

ELEGANT THINGS

white coat worn over a violet waistcoat

from The Pillow Book of Sei Shonagon

ELEGANT THINGS
33 x 3.2 x 2.9cm (13 x 11/4in x 3/4in)
The finished book opens like an elegant Japanese fan.

right on all the pages; and finally, to add another color.

I made two sample pages by sticking Ingres paper to mounting board. The laid lines ran from top to bottom of the page, making a pleasant texture. I stuck black paper on one side of the board and white paper on the other. This seemed to work and the pages looked well proportioned and clean, so I decided to make the whole book, including the covers and title pages, in the same way. Fortuitously the alternating colors meant that both the covers were black.

The addition of a third color became important. I tried dots and spots here and there but no color was right, and to add a color to the clean black and white pages seemed intrusive. Eventually a piece of pink silk and a bottle of pink ink provided the inspiration, and the only possible place left to put them seemed to be on the edges of the paperboard.

Binding

The last decision to make was how to bind the pages together. Because they were long and narrow in shape, a conventional method would not be suitable. Until this point I had thought very little about the Japanese elements of the text, rejecting early ideas about kimonos and fans as being too obvious, but now that the page shapes and colors were rigorously defined, a fan-shaped method of opening was no longer so banal.

It was important to find an accurate method of fixing the pages together if the finished piece was to make a perfect block - black front and back with pink edges. Instead of looking at Japanese bookbindings, I thought about Japanese carpentry and the use of pegged joints. I punched a hole in the center of the left-hand edge of each page and pushed through a dowel painted the same pink as the page edges. To fix the dowel and to allow the pages to fan open, I drilled two holes and made pegs with matchstick.

All that remained was to work out the title page and for this I used white gouache and painted capital letters with sharp contrasts - very thin thins, largish but light serifs and slightly waisted uprights.

The book was made in the following order: cut board to size; color edges; cut paper to size; stick paper to board; write black on white paper; write white on black paper; punch holes; cut, paint and drill dowel; cut matchstick pegs to size, and assemble.

When the book was finished, an unplanned and unexpectedly elegant detail appeared. Where the black and white paper had been stuck to the board, very thin black and white lines alternately separated the pink edge, giving a subtle striped effect.

CALLIGRAPHIC BOOKS

Richard Middleton
MANUSCRIPT BOOK

*43.6 x 14.3cm (17 x
51/2in) open
Single section manuscript
book. Cover and envelope
are made from Fabriano
Roma paper. The writing
is done with a goose quill
using lamp black designers
gouache on Edmonds Blue
laid paper.*

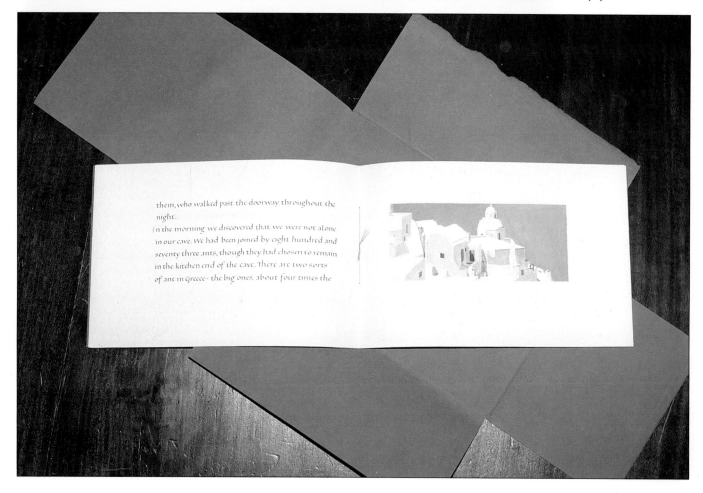

Susan Hufton
REVELATIONS OF
DIVINE LOVE

51 x 38cm (20 x 15in)
open
The outside boards of the
triptych are covered with
Japanese paper and the
letters are applied with a
pointed brush and
gouache. The inside boards
are covered with Bodlein
handmade paper and the
penmade letters are written
in gouache, moving
gradually from mauve to
green.

Georgia Deaver
Designed by Michael
Mabry
CHALLENGE
BROCHURE

21 x 35cm
(81/2 x 14in)
Steel pen and ink.

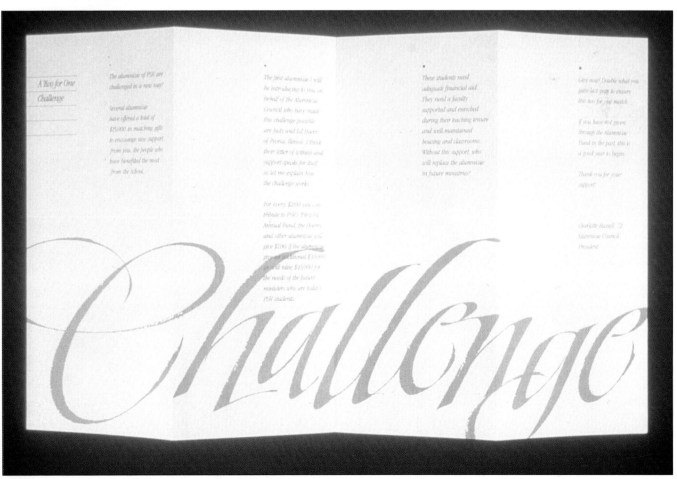

BOOKBINDING

THE binding of a book protects the pages and enables them to open. A delicate book, made from Japanese tissue can be protected by a delicate cover. This is because the tissue and the materials are compatible in strength. As a result the reader respects the book's fragility.

Japanese tissue binding

This book is adapted from the *Fukuro-toji* style. The book is made square to accommodate a letter of the alphabet on each page. The letters are painted in watercolor on the Japanese tissue.

One sheet of *koju-shi* tissue will make 12 leaves. Each leaf is double thickness with the fold at the foredge. This makes only 24 pages, so that four of the letters, such as "I" and "J" or "T" and "U" need to be paired up to save using another sheet of tissue.

Japanese tissue is made on a mold constructed from slats of bamboo tied together, which makes laid lines and chain lines similar to those in Western paper. This tissue is assumed to have a short grain

Fold a sheet of tissue 89 x 65cm (35 x 25½in) into 12 (above).

Trim to 28 x 14cm (11 x 5½in). Cut one long edge, mark a line 14cm (5½in) from it and cut the second edge (left).

The short edges can be cut square using the lines on a cutting mat or with a set square (right).

Use a page as a template, take some scissors and roughly cut out colored tissue for the cover. It should be double the size of the template (left).

Fold all the pages and the cover in half (right).

Make a second fold in the cover to allow for the thickness of the pages (left).

direction, running parallel with the chain lines. As with all books the paper is cut so that the grain direction is parallel with the spine.

When the pages are cut and folded, fit the book neatly inside the cover by knocking up the edges on the work bench. Mark a line between 6-10mm ($1/4$+$3/8$in) in from the spine and mark four holes along this line: one at the head and one at the tail (these should be the same distance from the edge as from the spine; the other two holes spaced evenly between them).

Use a pair of dividers to set the distance.

Use an open page to cut cover on long edges and at 28cm (11in) from center folds (left).

Fold the cover in to the central folds (right).

Work the sewing in a figure of eight, tensioning the thread as you go. Finish by tying a reef knot (right).

The finished book (left).

The stab-stitching restricts the book's opening. This must be taken into account when spacing the letters of the alphabet on the page (right).

Pierce the holes with a thin awl. Thread a needle with the mercerized cotton and knot the thread on to the needle.

Single-section binding

Combining the weak pages of a single section binding with a tough cover made from millboard and leather can be a problem. One possible solution is to use thread to act as the only hinge between the two. In this way one can avoid creating a tension between the pages and the cover when the book opens.

A strip of thin leather, reinforced by a strip of aerolinen is sewn on to the pages using a figure of eight stitch (right).

The cover opens out separately from the pages, which are held only by the thread (left).

Multi-section binding

The purpose of a design binding is to attract the reader. The cover is a vehicle for the binder's self-expression. The binding itself needs to be protected in a box.

The problem of making the soft watercolor paper compatible with heavy boards and leather is solved by sewing each fold of paper on to a strong, flexible support, linen tapes, which are in turn attached to the boards. The linen tapes act as the hinges for the boards, rather than the leather. The leather has no part in the structure of the binding. The linen tapes also act as a flexible backbone for the pages so that they can open out flat.

With the cover open flat the leather strip is pasted out with starch paste. It forms a 45° mitred joint with the leather turn-ins of the cover (above).

The structure of the book

Text and bookbinding by William Taunton

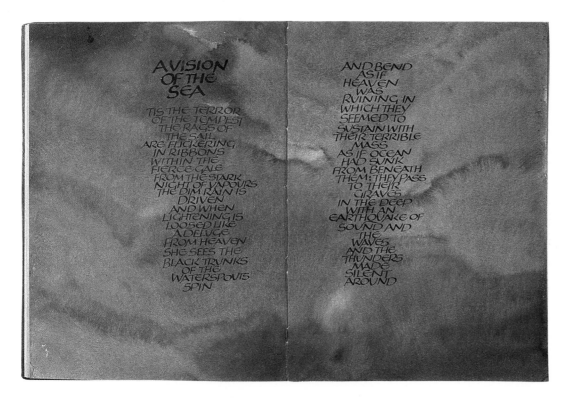

A VISION
OF THE
SEA

TIS THE TERROR
OF THE TEMPEST
THE RAGS OF
THE SAIL
ARE FLICKERING
IN RIBBONS
WITHIN THE
FIERCE GALE
FROM THE STARK
NIGHT OF VAPOURS
THE DIM RAIN IS
DRIVEN
AND WHEN
LIGHTENING IS
LOOSED LIKE
A DELUGE
FROM HEAVEN
SHE SEES THE
BLACK TRUNKS
OF THE
WATERSPOUTS
SPIN

AND BEND
AS IF
HEAVEN
WAS
RUINING IN
WHICH THEY
SEEMED TO
SUSTAIN WITH
THEIR TERRIBLE
MASS
AS IF OCEAN
HAD SUNK
FROM BENEATH
THEM; THEY PASS
TO THEIR
GRAVES
IN THE DEEP
WITH AN
EARTHQUAKE OF
SOUND AND
THE
WAVES
AND THE
THUNDERS
MADE
SILENT
AROUND

The calligraphy is written in dark blue watercolor on 300gsm (140Ib) watercolor paper over multi-colored watercolor washes (left and below).

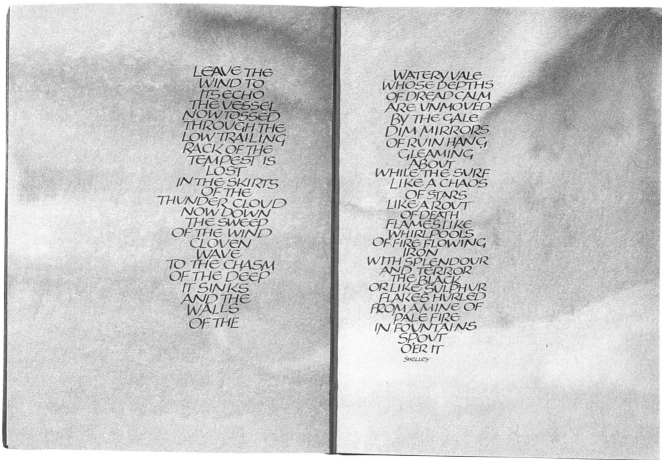

LEAVE THE
WIND TO
ITS ECHO
THE VESSEL
NOW TOSSED
THROUGH THE
LOW TRAILING
RACK OF THE
TEMPEST IS
LOST
IN THE SKIRTS
OF THE
THUNDER CLOUD
NOW DOWN
THE SWEEP
OF THE WIND
CLOVEN
WAVE
TO THE CHASM
OF THE DEEP
IT SINKS
AND THE
WALLS
OF THE

WATERY VALE
WHOSE DEPTHS
OF DREAD CALM
ARE UNMOVED
BY THE GALE
DIM MIRRORS
OF RUIN HANG
GLEAMING
ABOUT
WHILE THE SURF
LIKE A CHAOS
OF STARS
LIKE A ROUT
OF DEATH
FLAMES LIKE
WHIRLPOOLS
OF FIRE FLOWING
IRON
WITH SPLENDOUR
AND TERROR
THE BLACK
OR LIKE SULPHUR
FLAKES HURLED
FROM A MINE OF
PALE FIRE
IN FOUNTAINS
SPOUT
O'ER IT
SHELLEY

*End papers were made
from a fold of watercolor
wash paper (right).*

*The cover is dark blue
goatskin with colored
goatskin onlays that reflect
the sea imagery of the
poems (far right).*

*Tooled cover with onlays for
single - section binding
(below).*

LETTERING IN CUT PAPER

THE calligrapher learns that the shape of the letter derives directly from the use of the square-cut pen. Cut paper involves the use of a different tool, a sharp pair of scissors or a craft knife, and the character of the letter form changes accordingly.

In this project, the letters are cut freely in paper, without any preliminary drawing. It can be useful to use newsprint, as the printed columns give a rough guide to the size of the letter being cut, and letters cut in thin black paper work well. The basic form is that of a traditional letter, but natural variations arising from the use of the new tool are exploited and allowed to develop. The family relationships of letters, learned from calligraphy, are respected, but the character of the letter reflects the direct cutting action of a pair of scissors or a craft knife. This can result in a somewhat angular letter form and the round letters present interesting problems. *Alpha and Omega* and *Home Sweet Home*, show some ways in which this problem has been resolved. Letters cut with a knife will be subtly different in form from those cut with scissors.

Method

Work on soft board and stab-pin the cut-out letters into position on their appropriate background. Adjustments are easily made by altering or discarding and recutting the letters. They can be changed and moved around until the right balance between letter shape and space is achieved and you feel the whole design presents a satisfying unity. This method enables you to keep a careful watch on the background spaces, those important areas inside and between letters, between words and

ALPHA AND OMEGA
Pat Russell and Elizabeth Ford 68.5 x 280cm (8 x 21/3ft)
Hanging in free appliqué and machine stitching, based on cut paper letters (left).

HOME SWEET HOME
Pat Russell 30 x 56cm (161/4 x 221/4in)
Cut paper lettering was used as a pattern for a panel in layered and cut net and machine stitching, mounted on fabric (above).

between lines. Considerable patience and much hard work is required at this stage, but it is worth persevering until you are happy with the design. You can then paste down the letters accurately in position.

Alternative forms

Another form of cut-paper letter can be built up from small strips of paper, each element of the letter being cut separately. This method is extremely flexible and can result in original, lively lettering. Since these letters are not pen-made, the distribution of their thick and thin strokes need not necessarily correspond to that of traditional letter forms; instead their placing is governed solely by the demands of the design. This works well with both capital and lower-case letters. *Home Sweet Home* was designed in this way, the elision of the letter forms developing spontaneously from the method of design used. Two fabric versions are shown, each based on the original cut-paper master pattern, one in layered and cut net, the other in colored felts. In the second, the color emphasis is on the spaces between the lettering, giving an entirely different aspect to the design.

Cut-paper lettering may also be used in graphic design and the paper collage can stand as an art form in its own right. The use of torn paper provides added dimension, the characteristic rough edges and uncertain outlines producing letters of a very different nature from the cut variety.

Text and lettering by Pat Russell

HOME SWEET HOME
Pat Russell 38 x 46cm
(15 x 18in)
Small banner in colored felt. Color emphasis is on spaces between the letters (above).

BEVERLEY
Student's work in progress using torn paper. (Metchosin Summer School of Arts, Victoria, B.C.) Letters can be changed and moved until correct balance is achieved (right).

CALLIGRAPHY ON CLOTH

NO MAN IS AN ILA
INTIRE OF ITSELF
every man is a peece of the
a part of the MAINE; if a CLOD
away by the SEA, EUROPE is t
well as if a Promontorie were, a
MANNOR of thy FRIENDS or of T
were; any man's DEATH diminish
I am involved in Mankinde. And th
send to know for whom the BELL
for THEE. JOHN DONNE

Brenda Berman
NO MAN IS AN
ISLAND

61 x 46cm (24 x 18in)
Watercolor on Chinese silk.

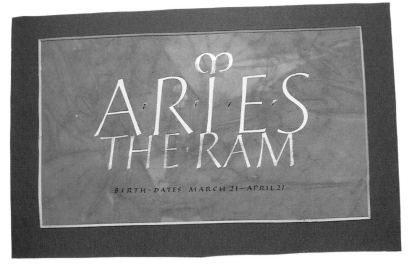

D

NTINENT,

e washed

lesse, as

ell as if a

NE OWNE

ME, because

efore never

ls; it tolls

3–1631

Denis Brown
ARIES

*20 x 13cm (8 x 5in)
Brush painted letters in
gouache and bronze powder
and raised and burnished
gold on gesso. Paper was
crumpled lightly while wet
and dyed. Where the paper
was creased more dye was
absorbed.*

Susan Hufton
WARM RAIN LADEN
EAST WIND

*120 x 87cm (47 x 34in)
Each panel 38 x 87cm (15
x 34in)
Detail from a triptych. The
background layer is of raw
silk with a leaf pattern
made by sponging gouache
around leaf-shaped
templates and then
embroidering the veins.
The remaining two layers
are of silk organza; the
watercolor letters have been
painted on the top layer
with a pointed brush.*

ALPHABET DESIGN

WHY bother to design new alphabets? Apart from the obvious benefits of experimenting free from any constraints, as a letter designer, my overriding interest has always been with the letter forms themselves and with an awareness that letters, as well as performing their function as "signs for sounds" can also be contemplated as pleasing in their own right. Alphabet designs stress this contemplative aspect and encourage the viewer's attention to turn towards the letter forms. The very familiarity of our alphabet means, unfortunately, that we seldom take the time to observe letters closely.

It is surprising how, even among some people who work with letters, the forms of letters are taken for granted as a fixed number of styles to be mastered: Roman, italic, uncial, and so on. It is as if letters are seen as something external to us, as shapes to be copied and not as forms which can be re-created in the imagination and therefore endlessly modified and adapted for different materials, processes and purposes. Through this internalizing operation, the art of letter making can be kept alive and perpetually renewed in the minds of each new generation. As A. K Coomaraswamy said, "it is of the essence of tradition that something is kept alive".

When working with the letters of the alphabet and considering the potential for varying the forms, I am constantly reminded of Herbert Read's remark on the abstract painting of Ben Nicholson: "The simplicity and fewness of the formal symbols employed by this artist do not constitute a limitation on his powers of invention - on the contrary he revels in the multiplicity of the variations he can command with these limited means".

Alphabet One

If you examine the first alphabet design, its most obvious element is the dynamic pattern which the letters make over the surface of the slate. The letters have affinities with classical inscription forms, both in their proportions and in having a stem width of about one-tenth of the letter height. With horizontal strokes about half the width of vertical stems and with the vestiges of calligraphic influence in, for instance, the shape of the bowls on "B", "P" and "R", the relationship with classical sources is further underlined. In other ways they clearly differ from traditional Roman letters, most

Having selected the most promising sketch, the alphabet was drawn on a larger scale of 28 x 11cm (11 x 41/2in) to clarify the idea and resolve design details (right).

The first step in designing Alphabet One was to make a series of rough 18 x 8cm (7 x 3in) sketches (bottom).

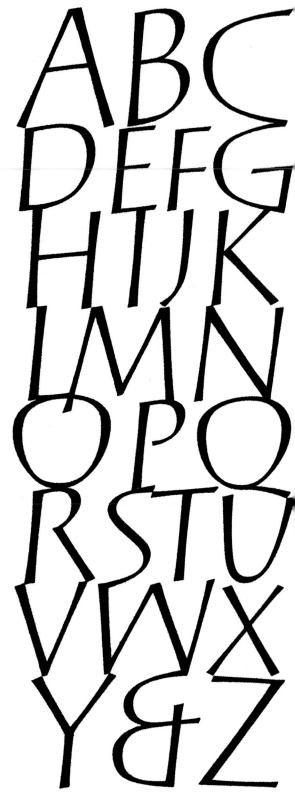

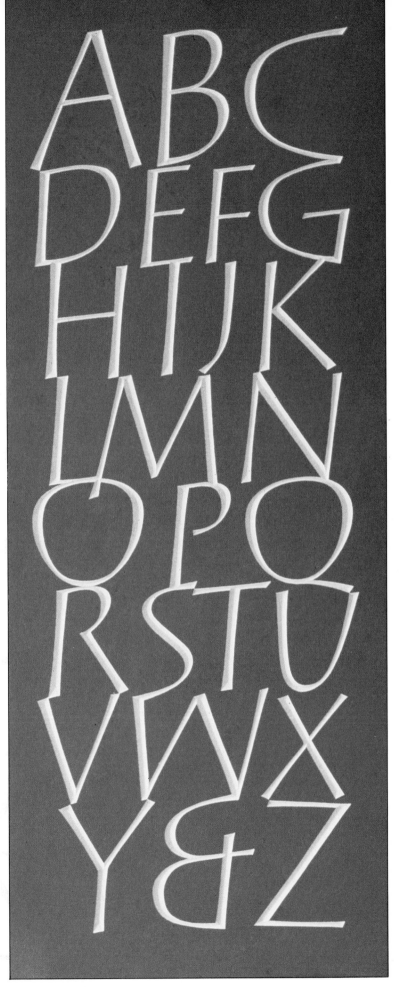

Final drawing scaled up to full size, with further design modifications (right).

ALPHABET ONE
56 x 22cm (22 x 9in) Incised on black slate, painted off-white using signwriters paint (left).

noticeably in the forms of "C", "G", "O", "Q", "S" and "U", the slope forwards and the lack of serifs, which gives the letters a more streamlined, pared-down quality.

Edward Johnston was concerned in his approach to his work and in his writings to give starting points (the Foundational hand being the obvious example) and to show that letter forms were "capable of great development".

The letters in Alphabet One can be seen as a development from Roman capitals. Comparing the "O" of a Roman letter with the "O" shape in this alphabet, you can see that while the former is more or less circular, the latter has a form which, though related to a circle, has a shape which has been slightly distorted, giving emphasis to the top part of the letter. It also has three thin points instead of the usual two. All this has the effect of making the form active within the rectangular format of the slate.

The "O", being the key for other curved forms, sets a pattern for curve formation throughout the design. "C "and "G" do not literally follow the shape of the "O" but preserve a relationship with it. "S has a close correspondence in structure with the "C" shape. Stems

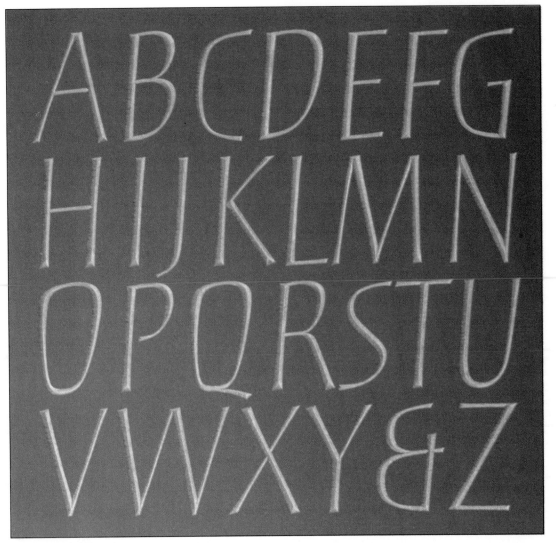

ALPHABET TWO
38 x 38cm (15 x 15in)
Incised black slate

are weighted slightly towards the top to enhance the sense of growth and movement.

Alphabet Two

This is a compressed and somewhat squarish-looking alphabet, which can be seen as an intermediate stage between the letters in Alphabet One and the tall, narrow letters in Alphabet Three. The letter "R" has changed from a straight-tailed form to one with a more flowing tail, which fits in more uniformly with the other letters. The square shape of the slate reinforces the shape of the forms.

Alphabet Three

This design is a combination of the forms in Alphabet One and a related, narrowed and angularized form, taking the idea of compression a stage further to produce a striking and unusual form. The piece is an experiment with different sizes, weights and forms of letters but depends on the fact that though different, the letter forms have a definite link with one another.

Finally, I experimented with three letters - "A", "R" and "C" - taking forms similar to the tall, narrow forms in Alphabet Three. These are used as a basis from which to develop an abstract arrangement of diagonal and curved lines of varying thickness which cut right through the edges of the slate.

I have tried to show, however briefly, something of how one idea leads to another and to suggest other possibilities. Each person will need to establish their own reference points and grow into their own perspective.

Text and letter carving by Tom Perkins

ARC
61 x 15cm (24 x 6in)
Incised black slate, painted
off-white (left).

ALPHABET THREE
48 x 15cm (19 x 6in)
Incised black slate, painted
off-white (right).

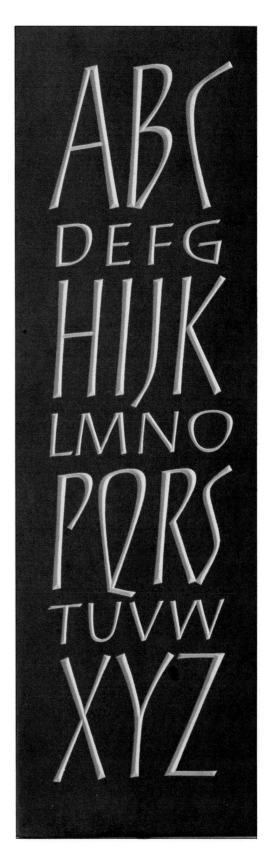

THE FOUR SEASONS

TRADITIONALLY, imagery has been combined with calligraphy to great effect, but often it results in a visual dichotomy between the writing and the illustration. In recent years, I have attempted to produce designs which combine calligraphy and imagery in such a way that the diverse elements are completely integrated.

Landscape seemed to offer the most appropriate basis for this approach and I began experimenting. I tried a seascape landscape with small writing superimposed in such a way that it was closely related to the tone of the background, allowing the words to be read only on close inspection. In two subsequent pieces, I used images which complemented the chosen texts without providing a literal or explicit correlation. In addition, I flattened the landscape, keeping the whole design as two-dimensional as possible, feeling sure that three-dimensionality had, in the past, been a cause of the dichotomy between the imagery and the flat, two-dimensional calligraphy.

These experiments provided the basis for *The Four Seasons*, produced during 1985. The four pieces evolved together. Words and images for each were selected from numerous sources which I had been perusing for more than two years.

I had been making sketches and taking photographs of landscapes for some time, without any direct reference to this project, thus there was readily available material for the images. The words were difficult to find. I

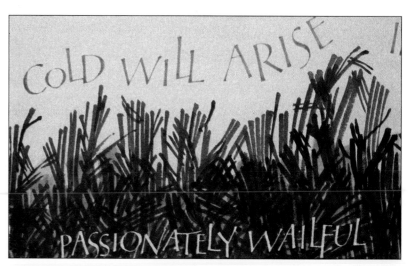

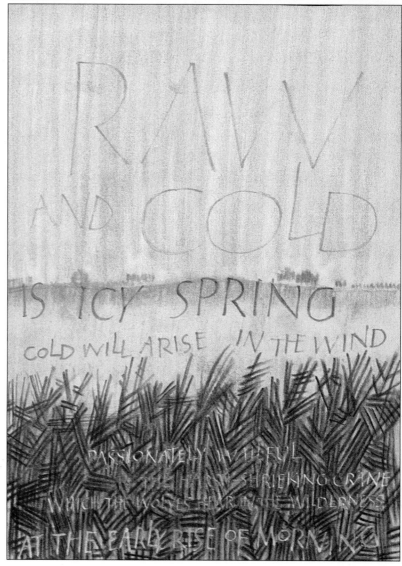

A detail from the finished piece showing how the lettering and landscape work together (above).

Photograph of the Clent Hills, Worcestershire, England taken at 8 am. This provided the inspiration for Spring.

The design, integrating landscape and lettering, was developed through a series of Conté pastel sketches (right).

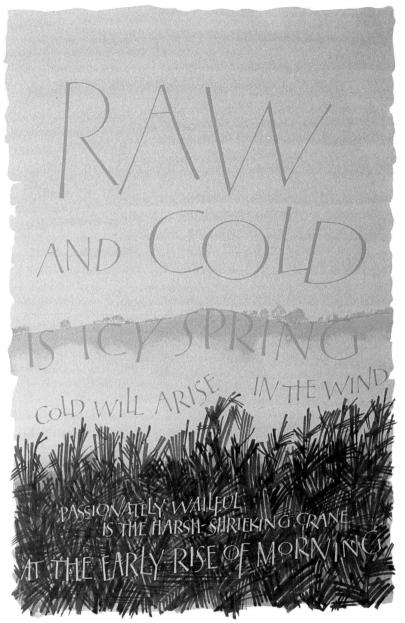

RAW AND COLD
IS ICY SPRING
COLD WILL ARISE IN THE WIND
PASSIONATELY WAILFUL
IS THE HARSH-SHRIEKING CRANE
AT THE EARLY RISE OF MORNING

SPRING

40 x 26cm

(153/4 x 101/4in)

The finished piece captures

the mood of the

photograph, which is

complemented by the 11th

century Irish verse (top).

A pastel sketch made while

on holiday in Burford,

South Wales (right).

needed fairly short texts about nature or the seasons which utterly avoided glibness and sentimentality. Gradually, I found myself drawn more and more towards ancient verse. Alison Urwick suggested a book of Celtic writings which seemed to be ideal, especially as most of my photographs and sketches had been made in Wales. The final four texts were narrowed down from a shortlist of 25. For the calligraphy, informal capitals of a modernized versal type provided the greatest flexibility for the sort of compositions I envisaged.

These elements provided the substance of the final paintings, and I was able to retain that emphasis on the words (or perhaps I should say the content), which is, I hope, characteristic of my approach to calligraphic design. The actual paintings took about six months to complete on a part-time basis. I used watercolor, largely unmixed from the tube, to achieve maximum brightness and clarity, so a not-pressed surface seemed the most appropriate. Disappointed by a number of English handmade papers, I turned to Arches Aquarelle, which I found to be extremely reliable. I stretched the 300 gsm (140 lb) stock to facilitate the laying of the watercolor washes. Watercolor is a risky medium, quite difficult to control, so I worked on two or three samples of each design at the same time to be sure of having one satisfactory result.

The technical methods used can best be shown by describing the approach taken for two of the individual pieces.

Spring

During 1982 and 1983, in all seasons, I had taken a series of photographs in the Clent Hills, Worcestershire which revealed a wide range of atmospheric, lighting and seasonal changes. One of these pictures taken early one morning, had unexpectedly turned out to be rather strangely green in color. This seemed to reflect perfectly the mood of one of the Celtic verses, so I produced some Conté pastel sketches, seeking compositional integration. From the best of these the final design was formulated and an outline tracing taken. Many color trials were done to achieve the right balance - Terre Verte and Prussian Green formed the basis of the color scheme. The sky wash was laid over the whole image area, and the large letters, the skyline and the

lower letters were traced in place and painted; the large letters with a small brush and the lower letters written with a steel pen using masking fluid. The middle letters were then traced in position and written with a pen. A patch of color was laid over the whole of the lower area to give density to the dark, separate brush strokes which represented the foreground trees. Finally, the masking fluid was removed to reveal the lighter tone underneath. The paper was taken from its board and separated from the gumstrip very carefully indeed in order to retain the original deckle edges.

Summer

On holiday in Wales in 1983, I had made some pastel sketches of the landscape and taken many photographs. The drawing of Bushford, with its strong coloring, seemed to capture the spirit of the Welsh verse. As with *Spring*, I made preliminary Conté pastel compositions to try to achieve the integration of the elements. At this stage, I enhanced the strength of the color. From the master outline

tracing the large letters and the individual areas of color were transferred on to the Aquarelle paper. Once the letters had been painted, using masking fluid, the main washes of color were laid down. The trees, hedgerows and other letters could then be traced and painted or written in their appropriate colors. When writing informal, built-up capitals at this size, having worked hard at the design stage to fit them comfortably together, I find it best to have some guide to size and position when writing the final piece. Sometimes I trace an outline (slightly narrower than the finished letter stems), sometimes just a skeleton form which can be fleshed out when writing. Working on top of color washes, laid on not-pressed paper, has its problems. It is difficult to write sharply (on some colors - for example, olive green - seemingly impossible) and there is little opportunity for correction - but in experimenting with this concept of letter and image integration some compromise has to be accepted. Finally, the masking fluid was removed and the paper taken off its board very carefully.

Text and calligraphy by Stan Knight

A detail of the finished piece showing how the landscape and the lettering harmonize to form an integrated image.

The holiday sketch became the basis of the design for Summer.

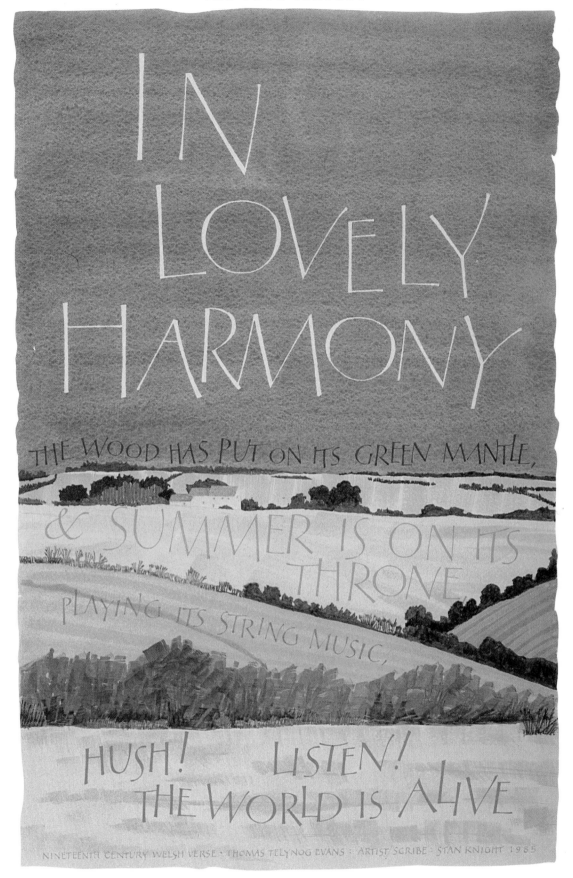

Summer
40 x 26cm (153/4 x 101/4in)
The strong coloring seems to capture the spirit of
Thomas Telynog Evans' 19th century verse.

TE DEUM LAUDAMUS

THE text for this piece was taken from *The Annotated Book of Common Prayer*, a late 19th-century book describing the history and development of the ritual and liturgy of the Church of England from its roots in the Early Christian Church.

My initial idea was to produce a panel of textures, the principal design element being the *Te Deum*, written out in three blocks, corresponding to its three sections. It would be written in English and Latin, six blocks in all, the title being used to separate the two versions. Comments and annotations relating to the hymn being added later as appropriate, from both a textual and design point of view.

First the entire hymn was written out to get a feeling for the quantity of text. This could subsequently be cut up and arranged as required. At this stage, it became evident that there were a number of design problems. The easiest way to obtain a block of text of the required size was, of course, to write out the text continuously, as if it were a piece of prose. But the hymn was not a piece of prose, and to force it into a prose format went against its sense, and made it uninviting and difficult to read. Also, the three sections of hymn are of unequal length, making it difficult to lay it out as I had first envisaged.

I therefore decided that each verse should occupy a line of its own. The verses are of greatly differing length, with the shorter ones tending to be towards the middle of the hymn, so that simply making a centered arrangement would have resulted in a rather unattractive outline of the text area. It seemed best to set the lines asymmetrically about the center, thus spreading out the shorter lines. The Latin text would be written in small capi-

The entire hymn was written out and cut into strips so that it could be pasted up and arranged in a suitable design

When all the elements of the design had been worked out, the next step was a paste up of the complete design (right).

The subtle color scheme for the lettering was based on that of medieval manuscripts (left).

TE · DEUM · LAUDAMUS

WE PRAISE THEE · O GOD:
we acknowledge thee to be the Lord
TE DEUM LAUDAMUS) TE DOMINUS CONFITEMUR

All the earth doth worship thee : the Father everlasting.
TE AETERNUM PATREM : OMNIS TERRA VENERATUR·

To thee all Angels cry aloud : the heavens and all the powers therein.
TIBI OMNES ANGELI · TIBI COELI ET UNIVERSAE POTESTATES·

To thee Cherubim and Seraphim · continually do cry,
TIBI CHERUBIN ET SERAPHIN : INCESSABILI VOCE PROCLAMANT·

Holy, Holy, Holy · Lord God of Sabaoth ;
SANCTUS · SANCTUS · SANCTUS · DOMINUS DEUS SABAOTH ;

Heaven and earth are full of the Majesty of thy glory·
PLENI SUNT COELI ET TERRA · MAJESTATIS GLORIAE TUAE·

The glorious company of the Apostles · praise thee.
TE GLORIOSUS APOSTOLORUM CHORUS·

The goodly fellowship of the Prophets · praise thee.
TE PROPHETARUM LAUDABILIS NUMERUS·

The noble army of Martyrs · praise thee
TE MARTYRUM CANDIDATUS · LAUDAT EXERCITUS·

The holy Church throughout all the world · doth acknowledge thee
TE PER ORBEM TERRARUM · SANCTA CONFITETUR ECCLESIA·

The Father of an infinite Majesty,
PATREM IMMENSAE MAJESTATIS·

Thine honourable, true and only Son ;
VENERANDUM TUUM VERUM · ET UNICUM FILIUM ;

Also the Holy Ghost · the Comforter·
SANCTUM QUOQUE PARACLETUM SPIRITUM

Thou art the King of glory · O Christ
TU REX GLORIAE · CHRISTE

Thou art the everlasting Son · of the Father·
TU PATRIS SEMPITERNUS ES FILIUS·

When thou tookest upon thee to deliver man ;
TU AD LIBERANDUM · SUSCEPTURUS HOMINEM :

thou didst not abhor the Virgin's womb
NON HORRUISTI VIRGINIS UTERUM·

When thou hadst overcome the sharpness · death·
TU DEVICTO MORTIS ACULEO ;

thou didst open the kingdom of heaven to all believers
APERUISTI CREDENTIBUS REGNA COELORUM·

Thou sittest at the right hand of God : in the glory of the Father·
TU AD DEXTERAM DEI SEDES : IN GLORIA PATRIS·

We believe that thou shalt come · to be our Judge
JUDEX CREDERIS ESSE VENTURUS·

We therefore pray thee · help thy servants :
TE ERGO QUAESUMUS · FAMULIS TUIS SUBVENI :

whom thou hast redeemed with thy precious blood
QUOS PRETIOSO SANGUINE REDEMISTI

Make them to be numbered with thy Saints : in glory everlasting·
AETERNA FAC CUM SANCTIS TUIS : GLORIA MUNERARI

O Lord · save thy people · and bless thine heritage
SALVUM FAC POPULUM TUUM · DOMINE : ET BENEDIC HAEREDITATI TUAE

Govern them · and lift them up forever
ET REGE EOS · ET EXTOLLE ILLOS USQUE IN AETERNUM

Day by day · we magnify thee
PER SINGULOS DIES · BENEDICIMUS TE

And we worship thy Name : ever world without end
ET LAUDAMUS NOMEN TUUM · IN SAECULUM ET IN SAECULUM SAECULI

Vouchsafe · O Lord · to keep us this day without sin
DIGNARE · DOMINE · DIE ISTO · SINE PECCATO NOS CUSTODIRE

O Lord · have mercy upon us : have mercy upon us
MISERERE NOSTRI · DOMINE · MISERERE NOSTRI·

O Lord · let thy mercy lighten upon us : as our trust is in thee
FIAT MISERICORDIA TUA · DOMINE · SUPER NOS : QUEMADMODUM SPERAVIMUS IN TE

O Lord · in thee have I trusted : let me never be confounded
IN TE · DOMINE · SPERAVI : NON CONFUNDAR IN AETERNUM

¶ Of the Canticles used in Divine Service, the Benedictus, the Magnificat and the Nunc Dimittis are inspired hymns spoken at the time when the Eternal Word was in the act of taking our nature to redeem and glorify it. The Te Deum is, if not inspired, the most wonderful expression of praise for the abiding Incarnation of our Lord that uninspired lips have ever uttered.

¶ This most venerable hymn has been sung by the whole Western Church day by day on all her feasts from time immemorial. It is found in our own Morning Service as far back as the conquest; and its insertion in the Salisbury Portiforium by St Osmund was doubtless a continuation of the old custom of the Church of England. Very ancient ecclesiastical traditions represent the Te Deum as a hymn antiphonally extemporised by St Ambrose and St Augustine at the baptism of the latter, AD 386. But the authorship has been assigned to several saints by both ancient and modern authors, the earliest being St Hilary of Poictiers, AD 355, and the latest, Nicetius, Bishop of Treves, AD 535. Some ancient copies, in the Vatican and elsewhere, give it the title Hymnus S. Abundii, and Hymnus Sisebuti monachi. It has also been attributed to St Hilary of Arles, and to a monk of Lerins, whose name is not known; the number of persons named shewing how much uncertainty has always surrounded the matter. It is scarcely possible that so remarkable a hymn should have originated in so remarkable a manner as that first referred to without some trace of it being found in the works of St Ambrose or St Augustine, especially the Confessions of the latter. It may be that their names were connected with it because the one introduced it into the Church of Milan, and the other taught by St Ambrose) into the Churches of Africa. ¶ For there is reason to think that the Te Deum Laudamus is much older than the time of St Ambrose. So early as AD 252 we find the following words in St Cyprian's Treatise On the Mortality that was then afflicting Carthage: Ah, perfect and perpetual bliss! There is the glorious company of the Apostles; there is the fellowship of the prophets exulting; there is the innumerable multitude of martyrs, crowned after their victory of strife and passion; and the striking parallel between them and the seventh, eighth, and ninth verses of the Te Deum seems certainly more than accidental. There are several coincidences also between words in the Baptismal and other offices of the Eastern Church and particular verses of the Te Deum, and and the former are supposed to be of extremely ancient date. In the Alexandrine MS of the Scriptures, a work of the fourth or fifth century preserved in the British Museum, there is moreover a Morning Hymn which is written at the end of the Psalter, and which is still used in the daily services of the Greek Church ¶ The first division of this hymn is identical with the Eucharistic Gloria in Excelsis, and the last verse is the Trisagion of the ancient Eastern Liturgies; the remaining portion has clearly a common origin with the Te Deum. Like the Te Deum, this ancient Morning Hymn of the Greek Church borrows largely from the Psalms in its concluding portion, and the verses chosen are of a supplicatory character in both, otherwise they do not correspond. ¶ The most probable conclusion to arrive at is, that this noble Canticle, in its present form, is a composition of the fourth or fifth century; and that it represents a still more ancient hymn, of which traces are to be found in St Cyprian and the Morning Hymn of the Alexandrine Manuscript.

A very striking characteristic of this heavenly hymn is the strictly doctrinal form in which it is composed: which makes it a literal illustration of St Paul's words, "I will sing with the spirit and I will sing with the understanding also." The first ten verses are an offering of praise to the Father Almighty, with the Scriptural recognition of the Blessed Trinity implied in the Ter Sanctus which Isaiah heard the Seraphim sing when he beheld the glory of Christ, and spake of Him. In the three following verses this implied recognition of the Three in One is developed into an actual ascription of praise to each, the Pater immensae Majestatis, the Unicus Filius, and the Sanctus Paracletus Spiritus. In these thirteen verses the Unity and Trinity of the Divine Nature is celebrated in the name of the whole Church of God. The Militant Church, the various orders of Holy Angels with which it has fellowship in the New Jerusalem, the Apostles, Prophets, and Martyrs of the Old and New Dispensations now gathered into the Church Triumphant, all thus adore God the Lord, the Lord God of Sabaoth, the Father Everlasting; and thus holy Church gathers up its praises in a devout acknowledgement of each Person of the Blessed Trinity as the Object of Divine worship. Then begins that part of the hymn which glorifies God for the blessing of the Incarnation: the latter sixteen verses addressing themselves to our Lord and Saviour; commemorating His Divine Nature and Eternal Existence, His Incarnation, Sacrifice, Ascension, and Session at the right hand of the Father. In the last verses, with a mixture of plaintiveness and triumph, the hymn follows the line marked out by the Angels at the Ascension, looking to our Lord's Second Advent as the true complement of His First. This concluding portion is as well fitted to express the tone of a Church Militant as the initial portion is to express that of a Church Triumphant; and the personal form of the last verse is a touching reminder of the individual interest that each of us has in the corporate work of praise and prayer of which Divine Service is constituted. Few uninspired compositions give so clear an echo of the spirit and depth of Holy Scripture.

The Te Deum is only known as connected with the ritual of the Church, and it seems also from the first to have been connected with the reading of the Morning Lessons. In the Salisbury Use, which probably represents the more ancient use of the Church of England, it was directed to be sung after the last lesson on Sundays and other Festivals, except during Advent and the Lenten season from Septuagesima to Easter. The Prayer Book of 1549 ordered it to be used daily throughout the year, except in Lent; and as Festivals were almost of previously daily occurrence, this was practically a continuance of the old rule. In 1552 the exception was erased, and has not since been restored.

Beside the use of the Te Deum in the Morning Service, there is a well-known custom of singing this triumphal hymn, by itself, arranged to elaborate music, as a special service of thanksgiving. It is directed to be used in this manner in 'Forms of Prayer to be used at Sea, After Victory, or deliverance from an Enemy'; and at the conclusion of coronations it is always so used, as it has been, time immemorial, in England, and over the whole of Europe. The Sovereigns of England have been accustomed to go in state to the singing of the Te Deum after great victories, and Handel's "Dettingen Te Deum" was composed for one of these occasions. Custom has also established this separate use of the Te Deum on other important occasions of thanks-

TE·DEUM·LAUDAMUS

WE PRAISE THEE, O GOD : WE ACKNOWLEDGE THEE TO BE THE LORD
TE DEUM LAUDAMUS : TE DOMINUS CONFITEMUR

All the earth doth worship thee : the Father everlasting.
TE AETERNUM PATREM : OMNIS TERRA VENERATUR.

To thee all Angels cry aloud : the heavens and all the powers therein.
TIBI OMNES ANGELI : TIBI COELI ET UNIVERSAE POTESTATES.

To thee Cherubin and Seraphin : continually do cry,
TIBI CHERUBIN ET SERAPHIN : INCESSABILI VOCE PROCLAMANT.

Holy, Holy, Holy : Lord God of Sabaoth;
SANCTUS, SANCTUS, SANCTUS : DOMINUS DEUS SABAOTH;

Heaven and earth are full of the Majesty : of thy glory.
PLENI SUNT COELI ET TERRA : MAJESTATIS GLORIAE TUAE.

The glorious company of the Apostles : praise thee.
TE GLORIOSUS APOSTOLORUM CHORUS.

The goodly fellowship of the Prophets : praise thee.
TE PROPHETARUM LAUDABILIS NUMERUS.

The noble army of Martyrs : praise thee.
TE MARTYRUM CANDIDATUS : LAUDAT EXERCITUS.

The holy Church throughout all the world : doth acknowledge thee;
TE PER ORBEM TERRARUM : SANCTA CONFITETUR ECCLESIA.

The Father : of an infinite Majesty;
PATREM IMMENSAE MAJESTATIS;

Thine honourable, true : and only Son;
VENERANDUM TUUM VERUM : ET UNICUM FILIUM;

Also the Holy Ghost : the Comforter.
SANCTUM QUOQUE PARACLETUM SPIRITUM.

✠

Thou art the King of glory : O Christ.
TU REX GLORIAE : CHRISTE.

Thou art the everlasting Son : of the Father.
TU PATRIS SEMPITERNUS ES FILIUS.

When thou tookest upon thee to deliver man :
TU AD LIBERANDUM, SUSCEPTURUS HOMINEM:

thou didst not abhor the Virgin's womb.
NON HORRUISTI VIRGINIS UTERUM.

When thou hadst overcome the sharpness of death :
TU DEVICTO MORTIS ACULEO:

thou didst open the kingdom of heaven to all believers.
APERUISTI CREDENTIBUS REGNA COELORUM.

Thou sittest at the right hand of God : in the glory of the Father.
TU AD DEXTERAM DEI SEDES : IN GLORIA PATRIS.

We believe that thou shalt come : to be our Judge.
JUDEX CREDERIS ESSE VENTURUS.

We therefore pray thee, help thy servants :
TE ERGO QUAESUMUS, FAMULIS TUIS SUBVENI:

whom thou hast redeemed with thy precious blood.
QUOS PRETIOSO SANGUINE REDEMISTI.

Make them to be numbered with thy Saints : in glory everlasting.
AETERNA FAC CUM SANCTIS TUIS : GLORIA MUNERARI.

✠

O Lord, save thy people : and bless thine heritage.
SALVUM FAC POPULUM TUUM, DOMINE : ET BENEDIC HAEREDITATI TUAE.

Govern them : and lift them up forever.
ET REGE EOS, ET EXTOLLE ILLOS USQUE IN AETERNUM.

Day by day : we magnify thee;
PER SINGULOS DIES, BENEDICIMUS TE.

And we worship thy Name : ever world without end.
ET LAUDAMUS NOMEN TUUM : IN SAECULUM ET IN SAECULUM SAECULI.

Vouchsafe, O Lord : to keep us this day without sin.
DIGNARE, DOMINE, DIE ISTO : SINE PECCATO NOS CUSTODIRE.

O Lord, have mercy upon us : have mercy upon us.
MISERERE NOSTRI, DOMINE : MISERERE NOSTRI.

O Lord, let thy mercy lighten upon us : as our trust is in thee.
FIAT MISERICORDIA TUA, DOMINE, SUPER NOS : QUEMADMODUM SPERAVIMUS IN TE.

O Lord, in thee have I trusted : let me never be confounded.
IN TE, DOMINE, SPERAVI : NON CONFUNDAR IN AETERNUM.

Of the canticles used in Divine Service, the Benedictus, the Magnificat and the Nunc Dimittis are inspired hymns spoken at the time when the Eternal word was in the act of taking our nature to redeem and glorify it. The Te Deum is, if not inspired, the most wonderful expression of praise for the abiding incarnation of our Lord that uninspired lips have ever uttered.

This most venerable hymn has been sung by the whole Western Church day by day on all her feasts from time immemorial. It is found in our own Morning Service as far back as the Conquest; and its insertion into the Salisbury Portiforium by St Osmund was doubtless a continuation of the old custom of the Church of England Very ancient ecclesiastical traditions represent the Te Deum as a hymn antiphonally extemporised by St Ambrose and St Augustine at the baptism of the latter, AD 386. But the authorship has been assigned to several saints by both modern and ancient authors, the earliest being St Hilary of Poictiers, AD 355, and the latest, Nicetius, Bishop of Treves, AD 535. Some ancient copies, in the Vatican and elsewhere, give it the title Hymnus S. Ambrosii, and Hymnus Saecular monachi. It has also been attributed to St Hilary of Arles, and to a monk of Lerins, whose name is not known; the number of persons named shewing how much uncertainty has always surrounded the matter. It is scarcely possible that so remarkable a hymn should have originated in so remarkable a manner as that first referred to without some trace of it being found in the works of St Ambrose or St Augustine, especially the Confessions of the latter. It may be that their names were connected with it because the one introduced it into the Church of Milan, and the other (taught by St Ambrose) into the Churches of Africa. For there is reason to think that the Te Deum Laudamus is much older than the time of St Ambrose. So early as AD 252 we find the following words in St Cyprian's Treatise On the Mortality that was then afflicting Carthage: Ah, perfect and perpetual bliss! Then is the glorious company of the Apostles; there is the fellowship of the Prophets exulting; there is the innumerable multitude of Martyrs, crowned after their victory of strife and passion; and the striking parallel between them and the seventh, eighth, and ninth verse of the Te Deum seems certainly more than accidental. There are several coincidences also between words in the Baptismal and other offices of the Eastern Church and particular verses of the Te Deum, and the former are supposed to be of extremely ancient date. In the Alexandrine MS of the Scriptures, a work of the fourth or fifth century, preserved in the British Museum, there is moreover a Morning Hymn which is written at the end of the Psalter, and which is still used in the daily service of the Greek Church. The first division of this hymn is identical with the Eucharistic Gloria in Excelsis, and the last verse is the Trisagion of the ancient Eastern Liturgies; the remaining portion has clearly a common origin with the Te Deum. Like the Te Deum, this ancient Morning Hymn of the Greek Church borrows largely from the Psalms in its concluding portion, and the verses chosen are of a supplicatory character in both, though otherwise they do not correspond. The most probable conclusion to arrive at is, that this noble Canticle, in its present form, is a composition of the fourth or fifth century; and that it represents a still more ancient hymn, of which traces are to be found in St Cyprian and the Morning Hymn of the Alexandrine Manuscript.

A very striking characteristic of this heavenly hymn is the strictly doctrinal form in which it is composed, which makes it a literal illustration of St Paul's words, I will sing with the spirit, and I will sing with the understanding also. The first ten verses are an offering of praise to the Father Almighty, with the Scriptural recognition of the Blessed Trinity implied in the Ter Sanctus which Isaiah heard the Seraphim sing when he beheld the glory of Christ, and spake of Him. In the three following verses, this implied recognition of the Three in One is developed into an actual ascription of praise to each, the Pater immensae Majestatis, the Unicus Filius, and the Sanctus Paracletus Spiritus. In these thirteen verses the Unity and Trinity of the Divine Nature is celebrated in the name of the whole Church of God. The Militant Church, the various orders of Holy Angels with which it has fellowship in the New Jerusalem, the Apostles, Prophets and Martyrs of the Old and New Dispensations now gathered into the Church Triumphant, all thus adore God the Lord, the Lord God of Sabaoth, the Father everlasting; and the holy Church gathers up its praises in a devout acknowledgement of each person of the Blessed Trinity as the Object of Divine Worship. Then begins that part of the hymn which glorifies God for the blessing of the Incarnation: the latter sixteen verses addressing themselves to our Lord and Saviour; commemorating His Divine Nature and Eternal Existence, His Incarnation, Sacrifice, Ascension, and Session at the right hand of the Father. In the last verses, with a mixture of plaintiveness and triumph, the hymn follows the line marked out by the Angels at the Ascension, looking to our Lord's Second Advent as the true complement of His First. This concluding portion is as well fitted to express the tone of a Church Militant as the initial portion is express that of a Church Triumphant; and the personal form of the last verse is a touching reminder of the individual interest that each of us has in the corporate work of praise and prayer of which Divine Service is constituted. Few uninspired compositions give so clear an echo of the spirit and depth of Holy Scripture.

The Te Deum is only known as connected with the ritual of the Church, and it seems also from the first to have been connected with the reading of the Morning Lessons. In the Salisbury use, which probably represents the more ancient use of the Church of England, it was directed to be sung after the last lesson on Sundays and other Festivals, except during Advent and the Lenten season from Septuagesima to Easter. The Prayer book of 1549 ordered it to be used daily throughout the year, except in Lent; and as Festivals were previously almost of daily occurrence, this was practically a continuance of the old rule. In 1552 the exception was erased, and has not since been restored. Besides the use of the Te Deum in the Morning Service, there is a well-known custom of singing this triumphal hymn, by itself, arranged to elaborate music, as a special service of thanksgiving. It is directed to be used in this manner in forms of Prayer to be used at Sea, after Victory, or deliverance from an Enemy; and at the conclusion of coronations it is always so used, as it has been, time immemorial, in England, and over the whole of Europe. The Sovereigns of England have been accustomed to go in state to the singing of the Te Deum after great victories, and Handel's Dettingen Te Deum was composed for one of these occasions. Custom has also established this separate use of the Te Deum on other important occasions of thanksgiving.

BASED ON THE REV. JOHN HENRY BLUNT, D.D. FROM HIS NEW EDITION OF THE ANNOTATED BOOK OF COMMON PRAYER, PUBLISHED IN LONDON IN 1903. THE IMAGE DESIGNED AND WRITTEN OUT ACCORDING TO THE TRADITIONAL METHODS BY DAVID HOWELL NICHOLLS, IN EAST GRINSTEAD, JULY 1989.

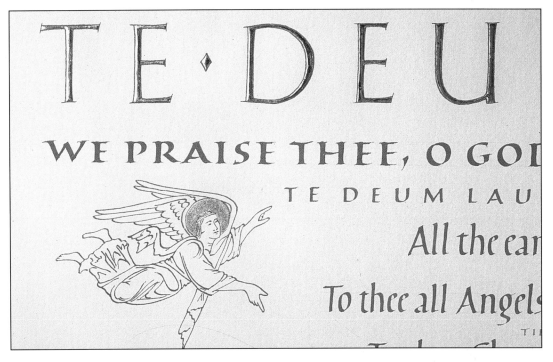

The uncolored pen-drawn illustrations are a feature of Anglo-Saxon manuscripts, while gilded and outlined capitals were used in the ninth century Second Bible of Charles the Bald (right).

TE DEUM LAUDAMUS 100 x 72cm (39 x 28in) The gilding, subtle colors and contrast between the lettering of the hymn and the gloss combine to form a harmonious whole (left).

tals between the lines of the English text. With this arrangement, the gloss would be placed in columns to the left and right, defining the edges of the panel. In addition, some form of illustration would be required, to lighten the large quantity of text.

The rough

With the principal elements decided, the first rough was put together. This revealed a number of problems, the chief of which was the large areas of white space. This needed to be dealt with by adjusting the size of the lettering. A portion of the text was written out in different weights and sizes so that the appropriate one could be selected. The columns of gloss were brought in closer to the main text, and given ragged left and right edges. This softened the boundary between the areas of text and space, further helping to reduce the visual impact of the space. The heading area was tightened up by putting the whole of the first verse of the hymn on to one line.

At this point, the color scheme was worked out. Given the ancient origins of the text, I felt that a color scheme based on the medieval manuscripts would be most appropriate. The subtlest colors are to be found in manuscripts of the Anglo-Saxon period, and these were adopted. Another attractive element of manuscripts of this period is the uncolored pen-drawn illustrations. The use of such illustrations here is appropriate, therefore, from both a historical and a design point of view; to have colored in these figures would have rendered them far too heavy. The gilded and out-

lined capitals were used in the Second Bible of Charles the Bald, in the ninth century. The outlining greatly increases their strength.

Ruling up

A piece of this size needs careful ruling up. In addition, the chosen paper (BFK Rives) has a rather soft surface, which makes it difficult to erase the pencil lines without damage. All lines were first ruled out on a sheet of layout paper and then the area occupied by text was removed. This provided a template which was used to rule up the final version, with rulings appearing only where lettering was to be written. These rulings were done very lightly so that it was not necessary to erase them. An additional advantage of this method is that, if for any reason you need to rule up a fresh version, you do not need to repeat all your measurements - you just reuse your template.

Ruling up the gloss, which was 96 lines long, presented a new set of problems. If you simply set your dividers to your line spacing and step off the required number of lines in the usual way, any errors will be repeated, 96 times in this case, and the error at the end will be considerable. It is preferable, therefore, to start by defining the top and bottom lines of the block. Then define the position of the mid-point line, then the quarter-point lines, and so on until all the lines have been marked up. In this way errors tend to be reduced rather than accumulated.

Text and calligraphy by David H. Nicholls

SPIRITUALITY AND LETTERING

SPIRITUALITY always deals with the particular and is uncomfortable with generalities. So I have chosen to introduce the subject with a specific project: the making of Easter banners for the Benedictine Abbey of Worth in Sussex, England. In this way I hope to give a feel of the sort of questions this area raises - questions many calligraphers face as they search for satisfaction in their work.

The church at Worth is built around a central altar, and can seat up to 2,000 people. The warm sandy-colored brick gives a light atmosphere to the building, and to complement this I chose light yellow and blue colors for the banners. Yellow and blue also symbolize light and water, key elements of the Easter liturgy. If the banners were to be readable from the back of the church, over 46m (150 ft) away, the letters would need to be large and simple. The clear lines of the building, the massive roof and brick columns also suggested a bold, clean-cut letter.

I began by doodling and sketching, and soon realized that the obvious Easter phrases like "Alleluia" or "He is risen" were not what I wanted. Also I came to feel that words which shouted or proclaimed a message were too assertive. I wanted words that people could use, words that had a contemplative space within them, words that people could pray with, whether by using their imaginations or by rhythmically turning them over in their minds, like a mantra. I imagined the banners

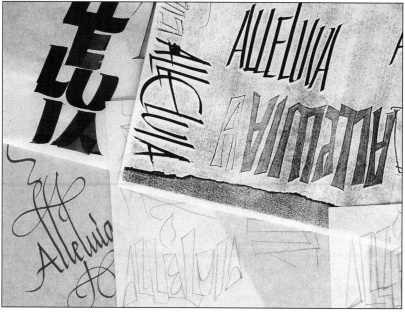

After experimenting with different words, weight and spacing a small-scale pencil sketch was made, refining the outline of a pen-written original (above and right).

The simple, bold lines and warm colors of the Worth Abbey brickwork give it a Middle Eastern feeling (left).

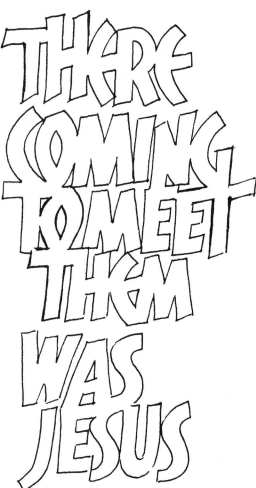

The banners hung on each side of the choir during Easter week. The light blue and yellow complemented rather than competed with the church's centers of liturgical action.

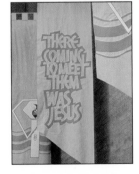

The finished banners were 3.3 x 0.9m (11 x 3ft). The lettered banner was flanked by two with light and water symbols (left).

DESIGN
18 x 10cm (7 x 4in)
Gouache and shell gold on vellum (below).

as a kind of visual chant, and chose the words, "There, coming to meet them, was Jesus." This, after remembrance of the crucifixion, would send shivers down any spine.

The banners were hung during the whole of Easter week and, as the Gospel stories of Christ's resurrection were read each day in church, so the banners' significance would change, each new story enriching them with fresh associations.

Making the banners

I decided on a block of lettering, positioned to balance with the light and water symbols on the other banners. These had already been designed by Richard Dennis, a member of the congregation at Worth. The lettering was for the central banner of each set of three. Thinking of the Abbey Church's bold architecture, I recalled some lettering I had seen on tombstones in Bavaria. I made my letters in a similar way, knowing they would be suitable for the cutting-out process I was using. Looking back on this design now, there is no doubt that I would make some of the letter shapes differently, particularly the "C" and some of the "O"s and "E"s. In addition, I would like to increase the width of the blue outlining in the top and left-hand side of the design.

I enlarged the design and transferred it on

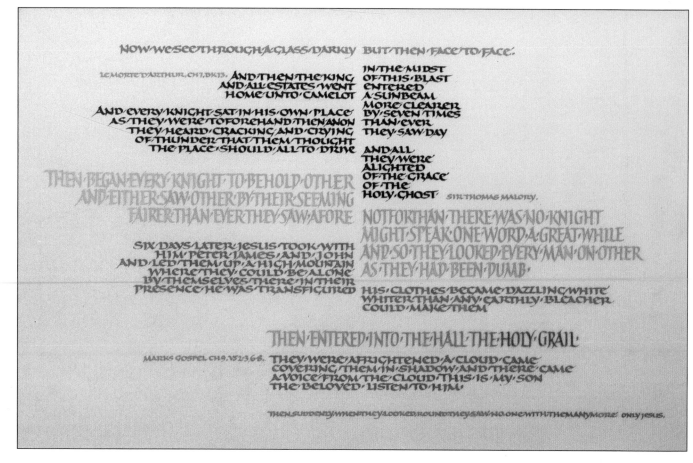

NOW·WE·SEE·THROUGH·A·GLASS·DARKLY BUT·THEN·FACE·TO·FACE:

LE·MORTE·D'ARTHUR, CH7, BK13. AND·THEN·THE·KING
AND·ALL·ESTATES·WENT
HOME·UNTO·CAMELOT

IN·THE·MIDST
OF·THIS·BLAST
ENTERED
A·SUNBEAM
MORE·CLEARER
BY·SEVEN·TIMES
THAN·EVER
THEY·SAW·DAY

AND·EVERY·KNIGHT·SAT·IN·HIS·OWN·PLACE
AS·THEY·WERE·TOFOREHAND·THEN·ANON
THEY·HEARD·CRACKING·AND·CRYING
OF·THUNDER·THAT·THEM·THOUGHT
THE·PLACE·SHOULD·ALL·TO·DRIVE

AND·ALL
THEY·WERE
ALIGHTED
OF·THE·GRACE
OF·THE
HOLY·GHOST SIR·THOMAS·MALORY.

THEN·BEGAN·EVERY·KNIGHT·TO·BEHOLD·OTHER
AND·EITHER·SAW·OTHER·BY·THEIR·SEEMING
FAIRER·THAN·EVER·THEY·SAW·AFORE

NOT·FOR·THAN·THERE·WAS·NO·KNIGHT
MIGHT·SPEAK·ONE·WORD·A·GREAT·WHILE
AND·SO·THEY·LOOKED·EVERY·MAN·ON·OTHER
AS·THEY·HAD·BEEN·DUMB.

SIX·DAYS·LATER·JESUS·TOOK·WITH
HIM·PETER·JAMES·AND·JOHN
AND·LED·THEM·UP·A·HIGH·MOUNTAIN
WHERE·THEY·COULD·BE·ALONE
BY·THEMSELVES·THERE·IN·THEIR
PRESENCE·HE·WAS·TRANSFIGURED

HIS·CLOTHES·BECAME·DAZZLING·WHITE
WHITER·THAN·ANY·EARTHLY·BLEACHER
COULD·MAKE·THEM

THEN·ENTERED·INTO·THE·HALL·THE·HOLY·GRAIL:

MARKS·GOSPEL·CH9, VS2,3,6,8. THEY·WERE·AFFRIGHTENED·A·CLOUD·CAME
COVERING·THEM·IN·SHADOW·AND·THERE·CAME
A·VOICE·FROM·THE·CLOUD·THIS·IS·MY·SON
THE·BELOVED·LISTEN·TO·HIM·

THEN·SUDDENLY·WHEN·THEY·LOOKED·ROUND·THEY·SAW·NO·ONE·WITH·THEM·ANY·MORE·ONLY·JESUS.

to the paperboard from which it was to be cut by redrawing it freehand. I had constructed a pen made from a 90-cm (3-ft) length of tongue and groove boarding with pencils taped securely to its two bottom edges. Having adjusted various parts of the lettering to strengthen the joints, I cut through the paper pattern into two layers of blue board, thus making two copies simultaneously. As I cut, I re-interpreted some of the forms. The whole design was cut out in one piece, a decision I regretted, as it then made sticking-down much more difficult. The cut-out paperboard was stuck to the cotton banners using a rubber-solution glue. It was a deliberate decision to use inexpensive materials and quick methods of production: the banners were to be temporary works with a limited life. New times would demand new banners.

The banners were hung on wooden dowel using Velcro to attach the material to itself. The dowel was capped with curtain rod finials.

Further designs

The banner project encouraged me to range beyond narrowly technical questions to ponder the value judgements that underpin my methods of work. The fact is that what we make and how we make it are intimately con-

nected with our relationship with ourselves, our fellow creatures and the world around us. Even if we do not articulate or are unconscious of the motives behind our work, the doing of it and the very way we choose to do it both fashion and reveal our motives. We have seen how this can be true for a large public work like the Easter banners, but what about our more personal calligraphic experiments?

In *Design*, using what I have learned with a pen about the unique combinations of volume, weight and stress that help us to characterize particular letters, I have reconstructed the letters indicating the same volumes, weights and stresses by different means. This is a very conceptual approach.

At the opposite end of the spectrum is the second piece, with words from *The Bacchae* of Euripides. Seized by a strange impulse I wrote these out during the space of one afternoon and evening. I have never written letter shapes like these before, nor have I since. The words come at the beginning of the play, reinforcing Pentheus's anxiety at the transforming power he senses in the stranger visiting his city. He senses an irrationality that is not containable. Pentheus cannot see that this dynamic of change is the dynamic of life itself. He risks destruction in opposing it. Although I wrote this at the same time as the

THE ENTRY OF THE HOLY GRAIL
46 x 33cm (18 x 13in)
Black stick ink, gouache and shell gold on stretched vellum.

Design piece, they differ markedly in character and approach.

I have learned through experience that the words I am drawn to work with invariably relate to unrecognized tensions and choices. They have a kind of prophetic prescience. In *Design* and the Pentheus piece, the scene had been set for two years of inner conflict that would culminate in my development of self-destructive cancer.

Looking back on the Holy Grail piece, I see now that the pivot of the whole design was a dramatic central split. The words brood around it and echo across it. Yet, although this was written at a time of great personal uncertainty and danger, it is hopeful because the theme that has come to fascinate me is transformation. This is indicated in the words that finally span the central divide, speaking of

Christ's transfiguration, and it is echoed in the arrival of the Holy Grail, symbol of the quest for wholeness. In resolving this design a new inner internal balance was struck.

So what we have seen here, on a more intimate scale than the banner project, are further examples of work being shaped not simply by narrowly technical situations but by a deeper level of activity. When it is articulated in a religious context, this level of activity that fashions and lays bare the quality of relationships we enjoy within ourselves, with our fellow creatures and the wider reality around us could be called our spirituality.

Learning about this spirituality, exploring and communicating with it through letter-making is what all master calligraphers have felt called to do. And as they did so, they discovered themselves being addressed by it in

WARNING TO
PENTHEUS
46 x 30cm (18 x 12in)
Gouache on Ingres paper.

the materials they used and in the words they wrote. And calligraphy became a revelation to them of themselves and the world in which they lived.

The thrust of these pages, therefore, has been to argue that sometimes to advance may mean to operate at a level other than that of acquiring and perfecting techniques. At some stage you will come to ask why this technique rather than that, and you will find no answer in the material facts around you. You will be forced down to the subjective level to decide or act for yourself. What are your grounds for action here? If you ask yourself this question, you will be at the point of departure for a new journey where your exploration of your art, yourself and your world have come together to form an inseparable whole. For a while you may reject conventional skills and be guided by a different sense of purpose - now this, now that - but you will remain bound to a Way, and in so doing you will advance.

Text and calligraphy by Ewan Clayton

A fragment - 31 x 19mm (11/4 x 3/4in) - from a piece, "I have come that you may have life and have it abundantly", using brushes and watercolor (right).

THERE ARE PALACES
20 x 15cm (8 x 61/2in)
Chinese black ink mixed with vermilion, shell gold, on 18th century hand-made paper, quill pen. Weeks of struggle with this commission were resolved when I thought my way into seeing the words not just as beautiful thoughts but as the statement of someone who had suffered.

CRUCIFIXION IS RESURRECTION
A fragment - 8 x 5cm (3 x 2in) - from a freely drawn piece using brushes and watercolor on paper (right).

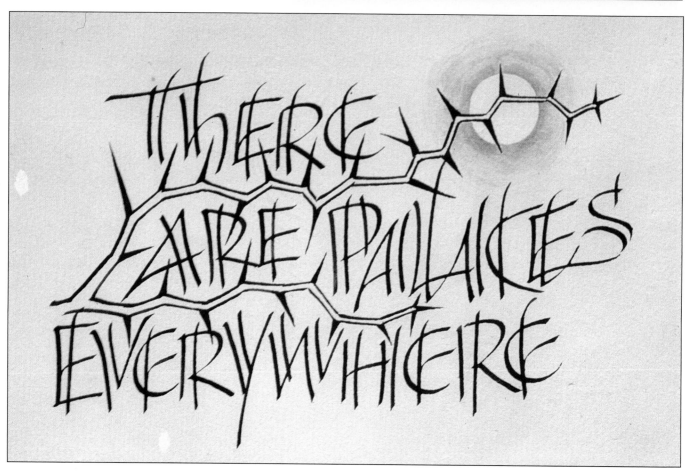

PAPER MOSAIC

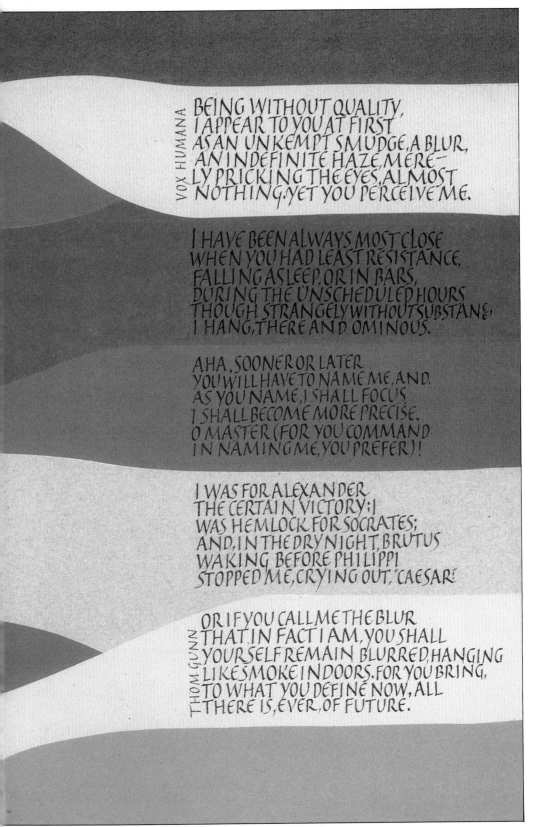

Tom Kemp
VOX HUMANA

47 x 30cm (18 x 12in)
Quill and Chinese stick ink
on a mosaic of colored
paper.

VOX HUMANA

BEING WITHOUT QUALITY,
I APPEAR TO YOU AT FIRST,
AS AN UNKEMPT SMUDGE, A BLUR,
AN INDEFINITE HAZE, MERE-
LY PRICKING THE EYES, ALMOST
NOTHING. YET YOU PERCEIVE ME.

I HAVE BEEN ALWAYS MOST CLOSE
WHEN YOU HAD LEAST RESISTANCE,
FALLING ASLEEP, OR IN BARS,
DURING THE UNSCHEDULED HOURS
THOUGH STRANGELY WITHOUT SUBSTANCE,
I HANG, THERE AND OMINOUS.

AHA, SOONER OR LATER
YOU WILL HAVE TO NAME ME, AND,
AS YOU NAME, I SHALL FOCUS
I SHALL BECOME MORE PRECISE.
O MASTER (FOR YOU COMMAND
IN NAMING ME, YOU PREFER)!

I WAS FOR ALEXANDER
THE CERTAIN VICTORY; I
WAS HEMLOCK FOR SOCRATES;
AND, IN THE DRY NIGHT, BRUTUS
WAKING BEFORE PHILIPPI
STOPPED ME, CRYING OUT, "CAESAR."

THOM GUNN

OR IF YOU CALL ME THE BLUR
THAT, IN FACT I AM, YOU SHALL
YOURSELF REMAIN BLURRED, HANGING
LIKE SMOKE INDOORS, FOR YOU BRING,
TO WHAT YOU DEFINE NOW, ALL
THERE IS, EVER, OF FUTURE.

VARIED EXAMPLES

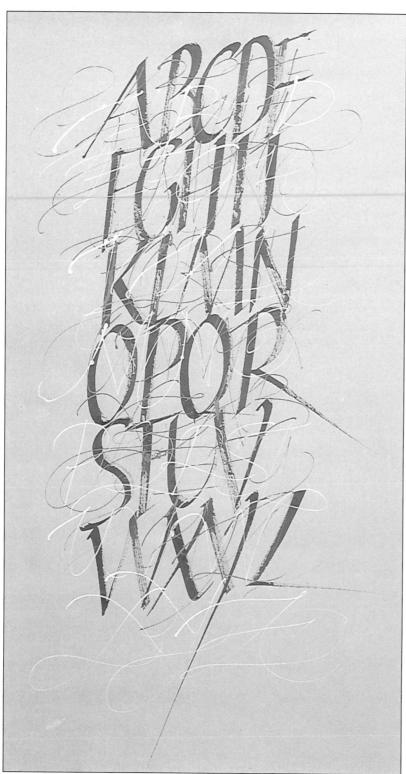

Gaynor Goffe
ALPHABET DESIGN

69 x 40.5cm (27 x 16in)
Ink and gouache on Ingres
paper, using an automatic
pen.

David Nicholls
(Oxford)
SHAKESPEARE
QUOTATION

15cm (6in) diagonal
Gouache on Japanese
paper; iridescence of frame
produced with anyline
dyes.

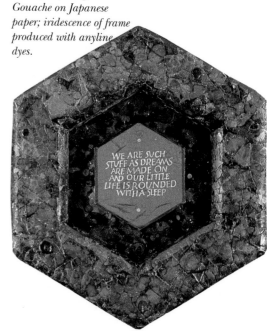

Cindy Wonnacott
CHAIN MAIL

75 x 40.5cm (29 1/2 x 16in)
Metal nibs on Ingres paper.
Gouache and resist.

firs of all the wet plain
extremely cold
rought me forth from
its interior
I know in my thoughts
that I was not made
by excellent ski
from fleeces of wool
or from hairs
woofs are not wound for me
nor have I a warp
nor for me does a thr
resound from the
force of many
strokes
r does the whirring
shuttle glide
over me
nor all weavers
rods strike me
from anywhere
the worms that deck
the fine yellow cloth
with embroidery did not
weave me by the skill
that the fates had given
nevertheless before men
far and wide over the earth
I shall be called a
pleasing garment
say truly man skilled
in clever thoughts
and wise in words
this garment is

'a saxon coat of mail' 975

old english riddle in the exeter book

INDEX

ACKNOWLEDGMENTS

The author would like to thank Bob Kilvert for allowing
publication of his watercolor wash techniques for
the first time. Those interested in exploring these techniques
further can attend one of the courses he runs at
The Old Corner House, Broad Street, Weobley, Hereford HR4 8SA.
The author and publisher would also like thank the following
people and organizations:

pp 8-12 The Dean of St Albans Cathedral; **p 17** Bridgeman Art
Library; **pp 24-9** *Everybody's Wine Guide* by Anthony Hogg, Quiller
Press. Maps reproduced by permission of Peter Dominic; **p33** Pollock
and Searby Ltd; **p35** Messrs C. Hoare & Co; **p41** (bottom) *David H.*
Nicholls; **p 72-6** Reference should be made to Sam Somerville's excel-
lent chapter in *The Calligrapher's Handbook,* 'Parchment and Vellum'.
Expanded from an article published in *The Scribe,* No 44.;
p 77 (top) First illustrated in *The Scribe,* No 43; **p 85** (bottom) *Chinese*
Poems by Arthur Waley. Unwin Hyman; **p 106-7** *The Pillow Book of Sei*
Shonagon edited and translated by Ivan Morris (Penguin Classics
1967) © Ivan Morris, 1967 Reproduced by permission of Penguin
Books Ltd; **p 109** (top) *Revelations of Divine Love* by Julian of Norwich,
translated by Clifton Wolters (Penguin Classics, 1966) © Clifton
Wolters, 1966 Reproduced by permission of Penguin Books Ltd; **p119**
(bottom) Reprinted by permission of Faber and Faber Ltd from
Markings by Dag Hammarskjold translated by W.H. Auden and Leif
Sjoberg; **pp 138-9** Reprinted by permission of Faber and Faber Ltd
from *The Sense of Movement* by Thom Gunn.